PICASSO
LITHOGRAPHS

61 Works by
Pablo Picasso

Dover Publications, Inc., New York

PUBLISHER'S NOTE

Pablo Picasso (1881–1973) had been a printmaker for some twenty years before creating his first lithographs in 1919, when he was 38. Between that year and 1930 he worked relatively little in the medium, though always fruitfully. Then followed another gap in lithographic production, lasting fifteen years. But when the "fever" to create lithographs attacked Picasso once more, late in 1945, it raged unabated as it never had before.

The sizable oeuvre produced in the years after 1945 is amazing for its technical and thematic diversity. Always an inspired artisan as well as a great designer and incomparable draftsman, Picasso renewed many old lithographic techniques and invented new ones, working directly on zinc as well as stone, or doing his drawing on transfer paper, either in a traditional manner or else handling the paper like a collage or treating it in other novel ways. The extremely numerous states of many lithographs attest to his thirst for perfection, for the optimal solution of every compositional and technical problem.

Picasso's lithographic subject matter included just about all the great themes associated with him: portraits; images of artists, their models and their studios; still lifes; studies of children and animals (especially the famous doves); Greco-Roman mythology; bullfights; poster designs; variations on classic paintings. In the 1954 group at the end of the present volume, the drawing style and subject matter surprisingly recall the years around 1905, with the actors, street acrobats, toreadors and baboons that the young master had so often lovingly rendered.

Copyright © 1980 by Dover Publications, Inc.
All rights reserved under Pan American and
International Copyright Conventions.

Published in Canada by General Publishing Company, Ltd.,
30 Lesmill Road, Don Mills, Toronto, Ontario.
Published in the United Kingdom by Constable and Company, Ltd.

Picasso Lithographs, first published by Dover Publications, Inc.,
in 1980, is a new selection from a number of published sources.

International Standard Book Number: 0-486-23949-7
Library of Congress Catalog Card Number: 79-54809

Manufactured in the United States of America
Dover Publications, Inc.
180 Varick Street
New York, N.Y. 10014

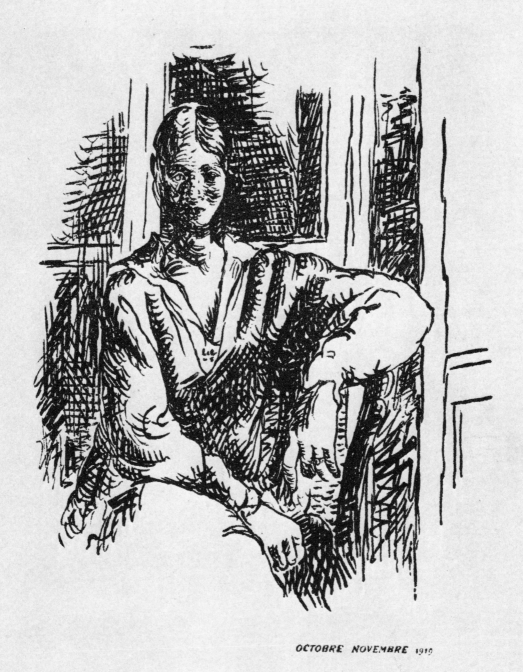

EXPOSITION DE DESSINS ET AQUARELLES
Par PICASSO

OCTOBRE NOVEMBRE 1919

WOMAN SEATED BY A WINDOW. For the cover of the catalogue of a Picasso show at the Paul Rosenberg gallery, 1919. Litho ink on transfer paper transferred to stone. 20 x 17 cm (7⅞ x 6¾ inches).

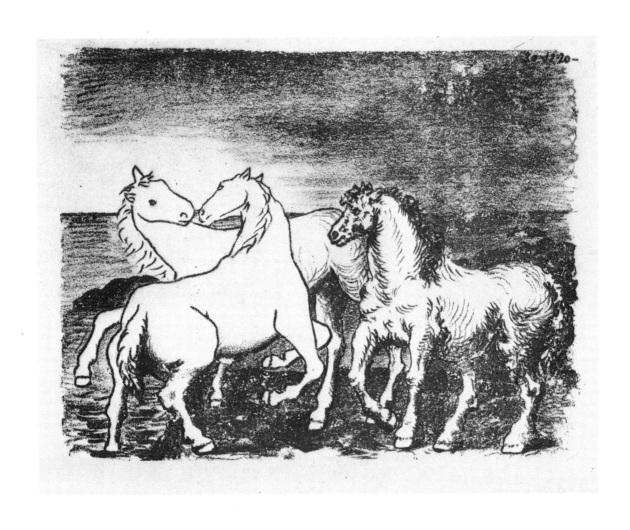

Above: THREE HORSES BY THE SEASHORE. 1920. Crayon on litho paper transferred to stone. 12.5 x 16.5 cm (4⅞ x 6½ inches). *Opposite, top:* PORTRAIT OF THE POET PAUL VALÉRY. 1920. Crayon on litho paper transferred to stone. 10.3 x 8 cm (4⅛ x 3⅛ inches). *Opposite, bottom:* PORTRAIT OF THE NOVELIST RAYMOND RADIGUET. 1920. Litho crayon on transfer paper; reproduced in collotype as the frontispiece to Radiguet's *Les joues en feu,* 1925. 11.5 x 9.8 cm (4½ x 3⅞ inches).

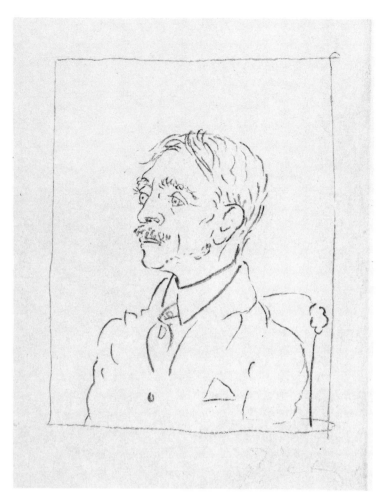

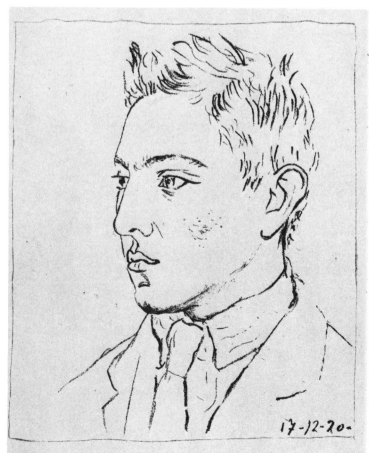

17-12-20-

3

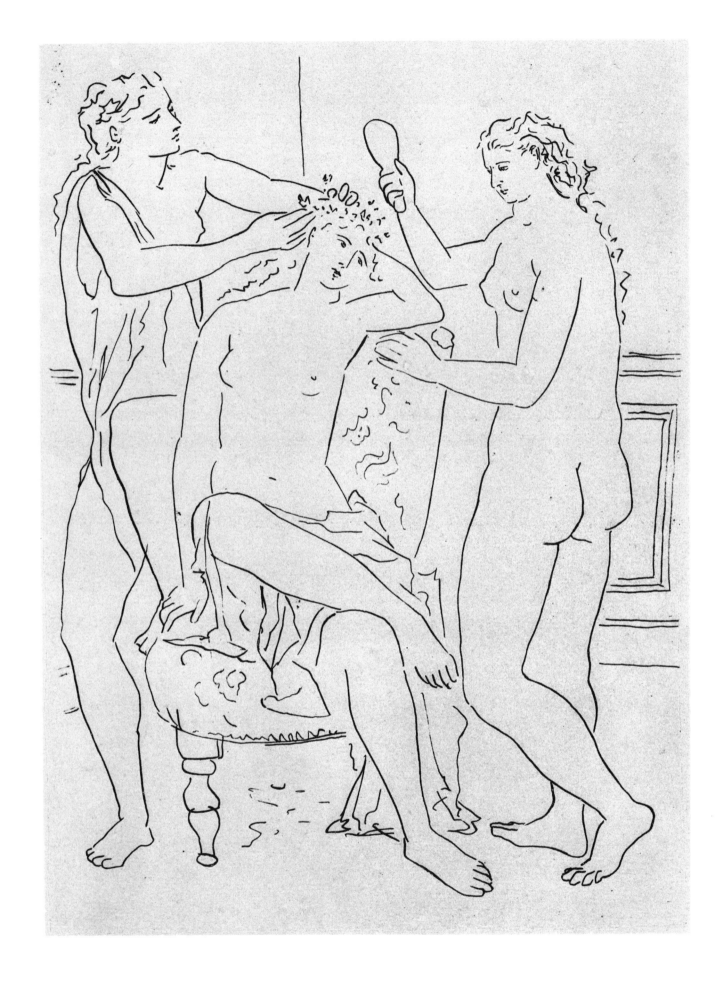

THE WREATH OF FLOWERS. 1923. Crayon on stone. 29.7 x 23.8 cm
(11¾ x 9⅜ inches).

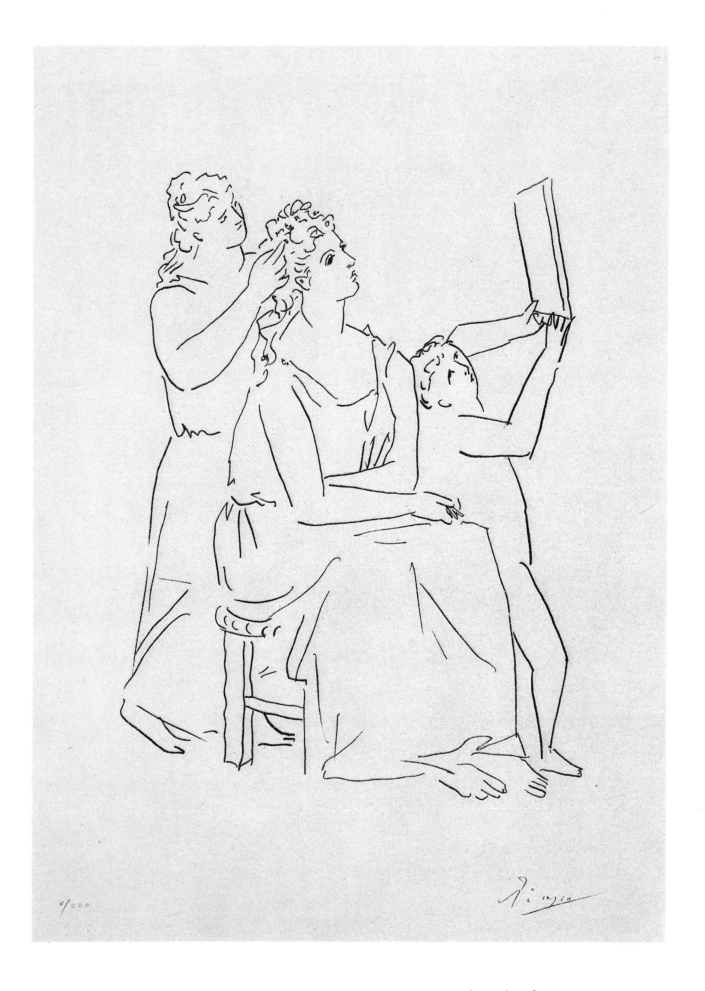

HAIRDRESSING. 1923. Crayon on stone. 27 x 20.4 cm (10⅝ x 8⅛ inches).

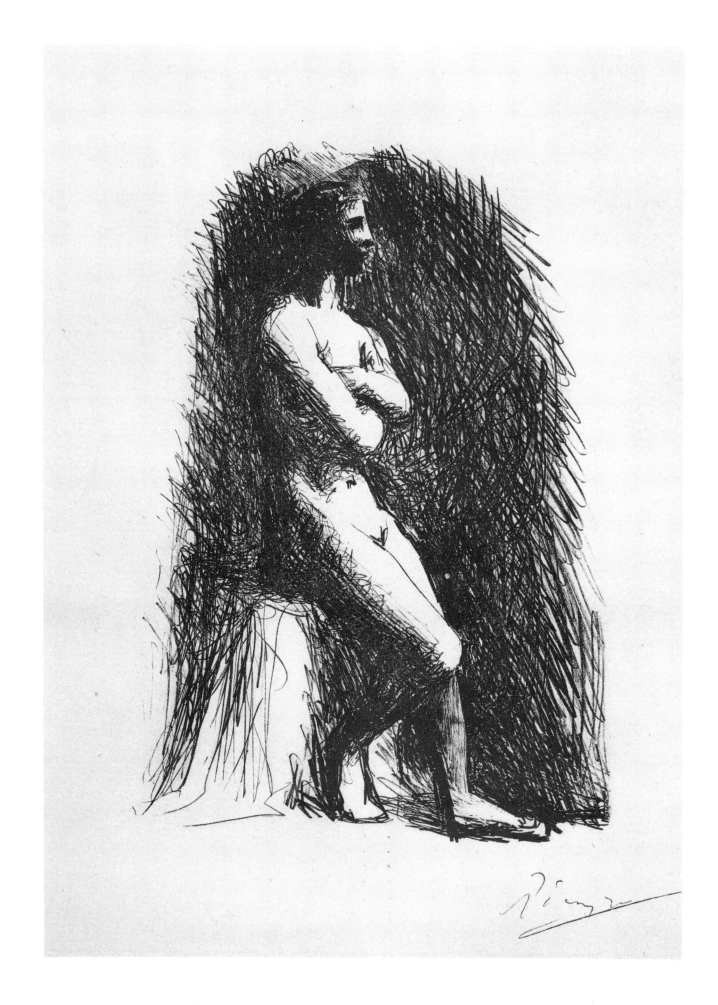

SEATED WOMAN. 1924. Crayon on stone. 29.5 x 21 cm (11⅝ x 8¼ inches).

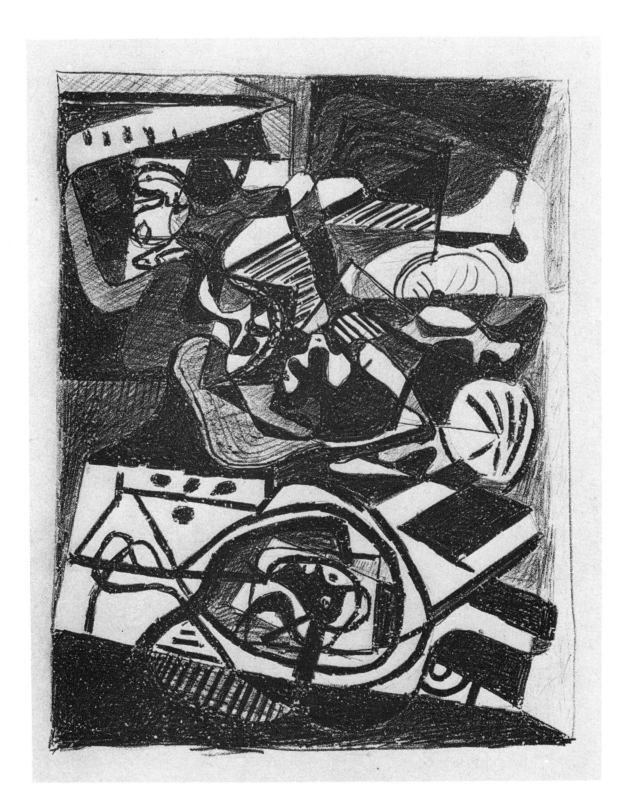

INTERIOR. 1926. Crayon on stone. 22.3 x 28 cm (8¾ x 11 inches).

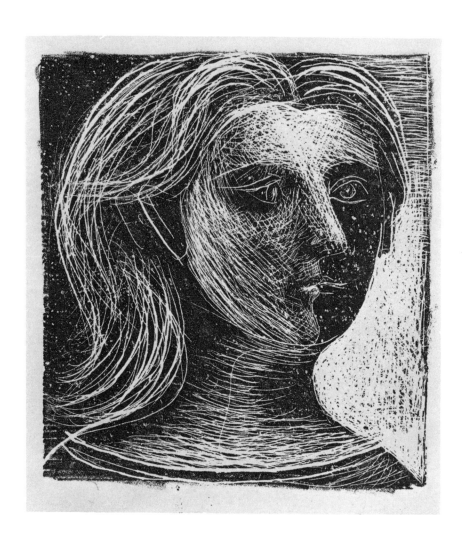

WOMAN'S HEAD. 1925. Appeared in 100 copies of Waldemar George's book *Picasso, Dessins*, 1926. Crayon on stone, the whites achieved by a scraper. 12.7 x 11.5 cm (4½ x 5 inches).

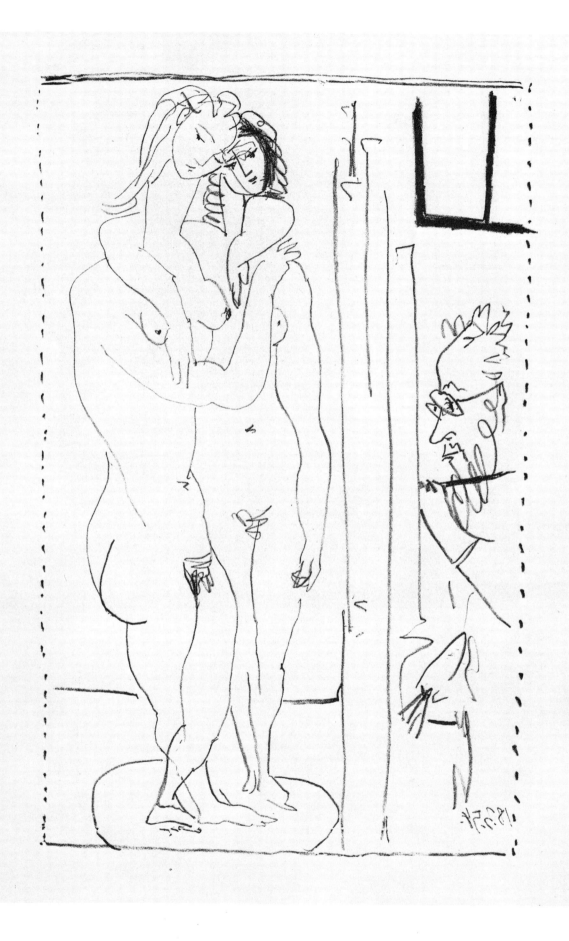

THE TWO NUDE MODELS. 1954. Litho crayon on transfer paper transferred
to stone. 58 x 38 cm (22⅞ x 15 inches).

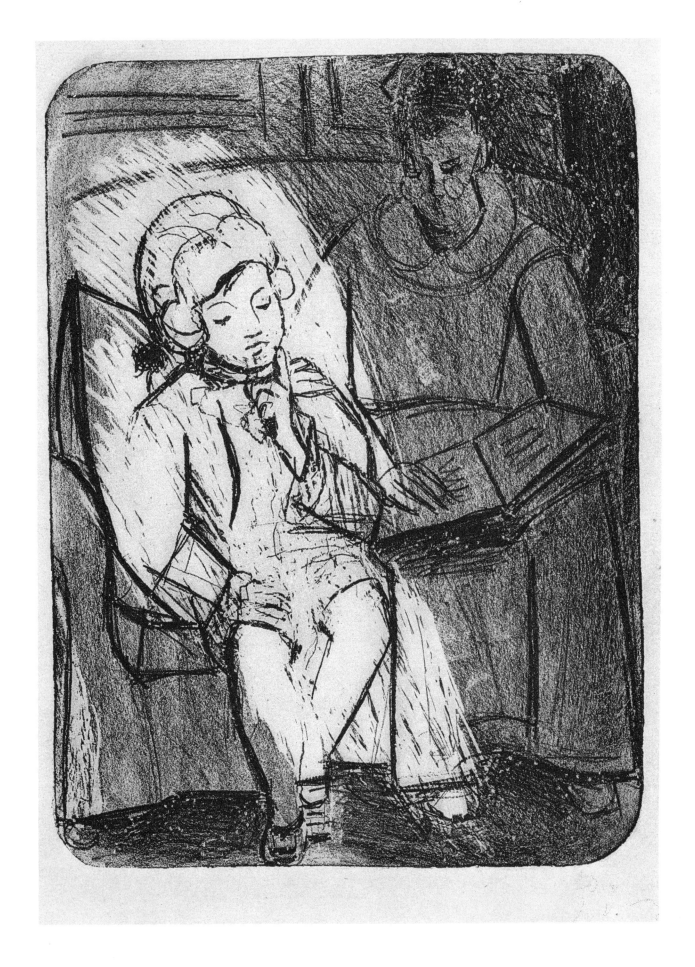

READING. 1926. Crayon on stone. 32.7 x 24.5 cm (12⅞ x 9⅝ inches).

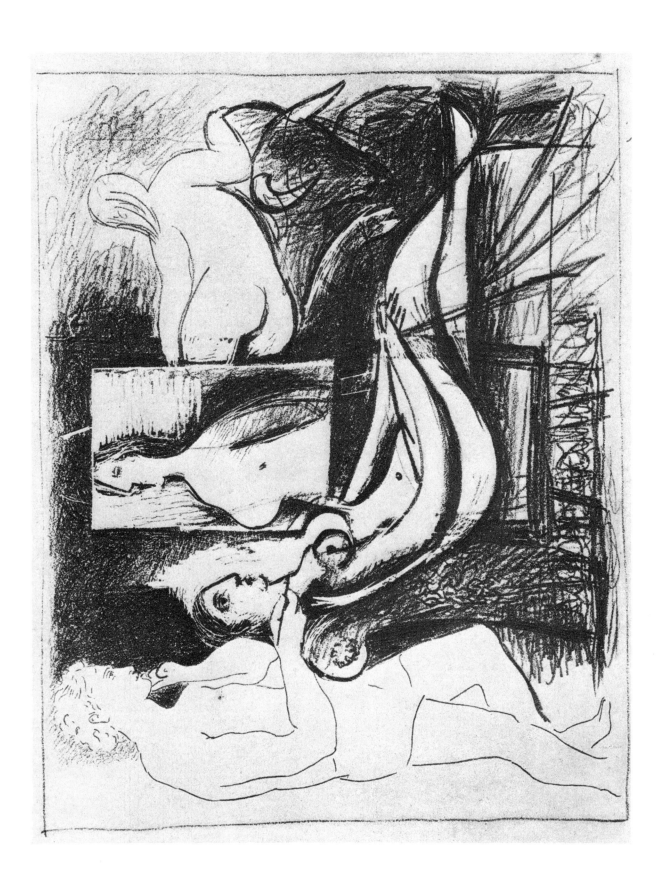

THE PAINTER AND HIS MODEL. Appeared in the luxury edition of *Pablo Picasso* by Eugenio d'Ors, 1930. Crayon on stone. 23.2 x 28.9 cm (9⅛ x 11⅜ inches).

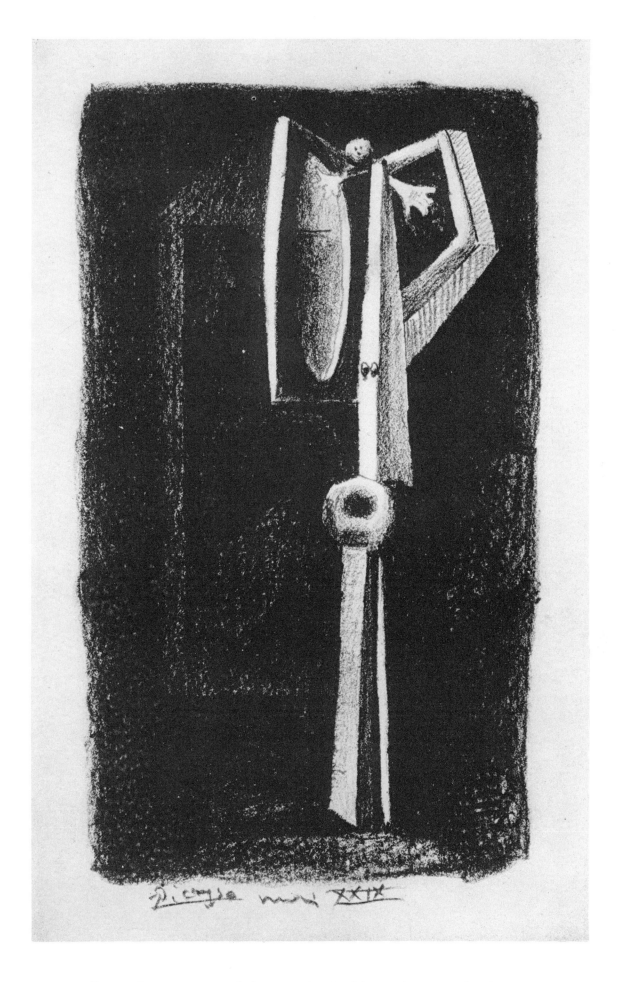

FIGURE. For 300 copies of the magazine *Le Manuscrit autographe,* 1929.
Crayon on stone. 23.7 x 13.8 cm (9⅜ x 5½ inches).

THE TWO NUDE WOMEN. Third state, November 1945. Wash and pen on stone, with scraper work. 25 x 33 cm (9⅞ x 13 inches).

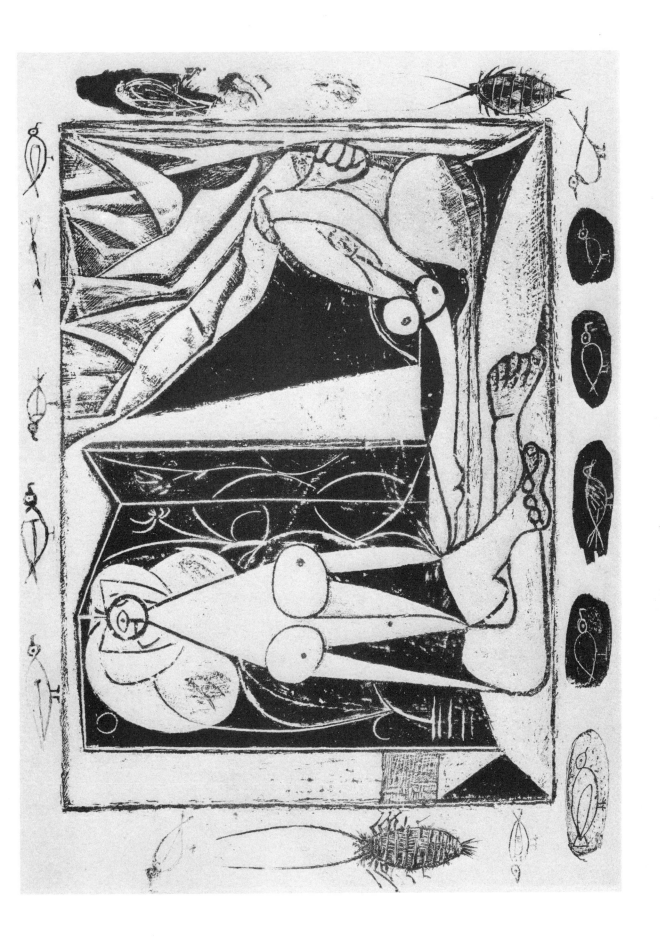

THE TWO NUDE WOMEN. Eighteenth and final state, February 1946.

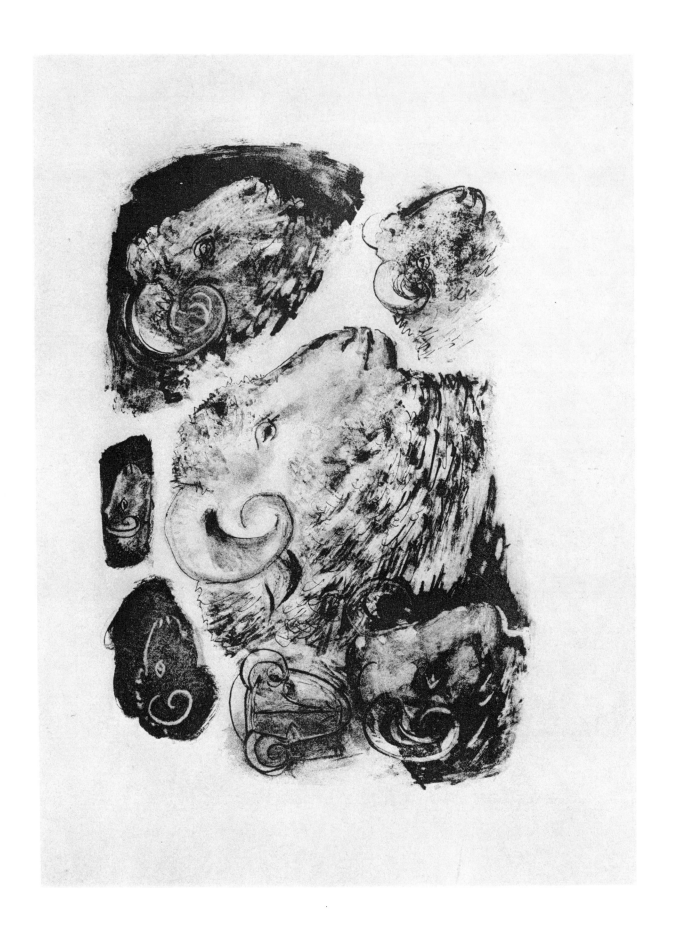

HEADS OF RAMS. 1945. Wash and pen on stone. 23 x 34 cm (9⅛ x 13⅜ inches).

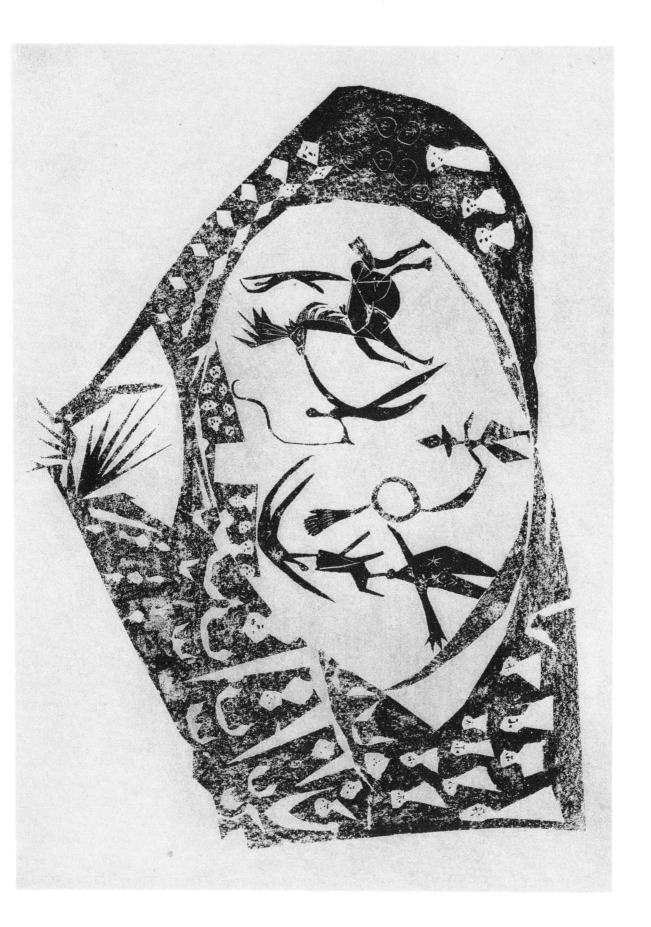

THE CIRCUS. 1945. Second state. Ink on litho paper that was cut and pasted and transferred to stone; scraper work in some areas. 29 x 39 cm (11⅞ x 15⅜ inches).

BLACK PITCHER AND DEATH'S-HEAD. 1946. Crayon and ink on litho paper transferred to stone, with scraper work. 32.5 x 44 cm (12⅞ x 17⅜ inches).

20.1.47.

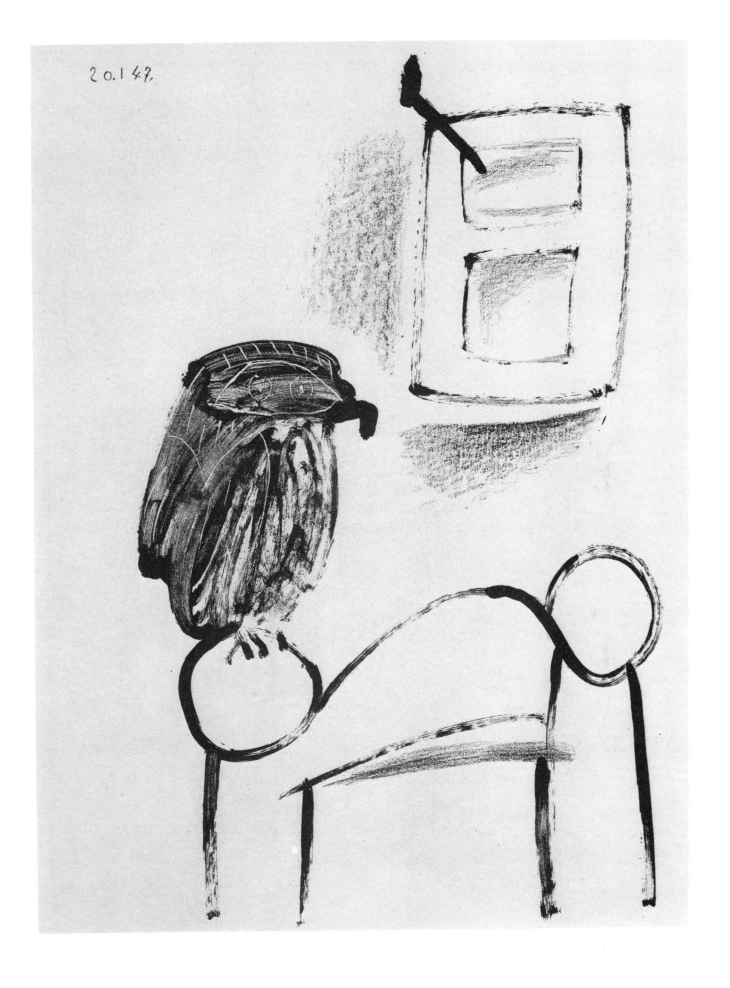

Owl on Chair, with White Background. 1947. Wash and rubbed crayon, with scraper work, transferred to stone. 64 x 42 cm (25⅛ x 16½ inches).

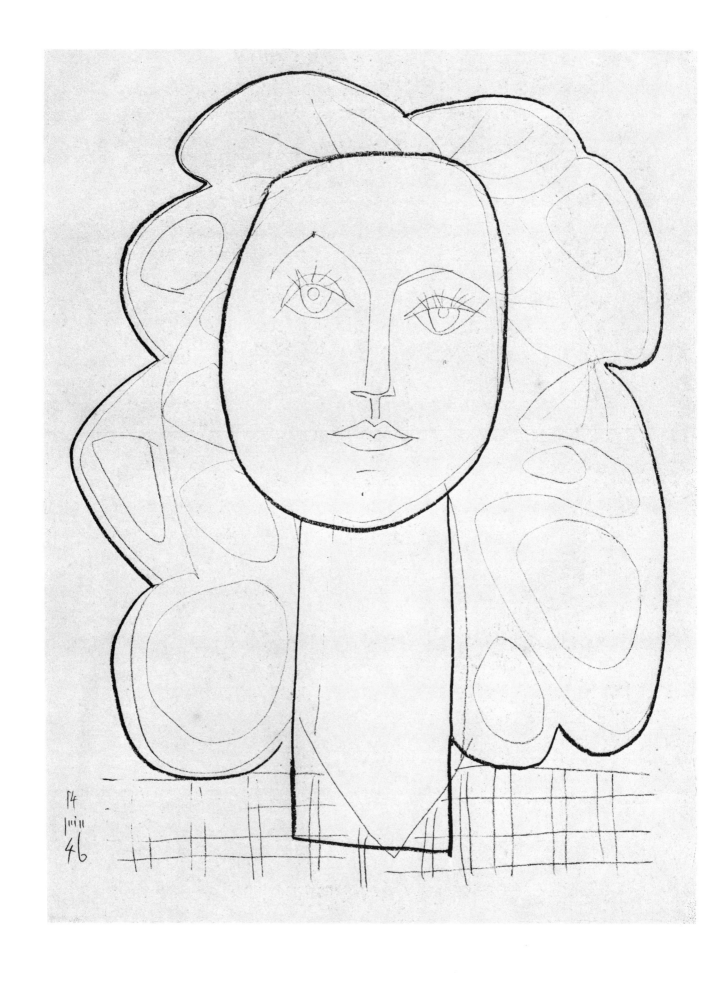

FRANÇOISE. 1946. Crayon on litho paper transferred to stone.
61 x 46 cm (24 x 18⅛ inches).

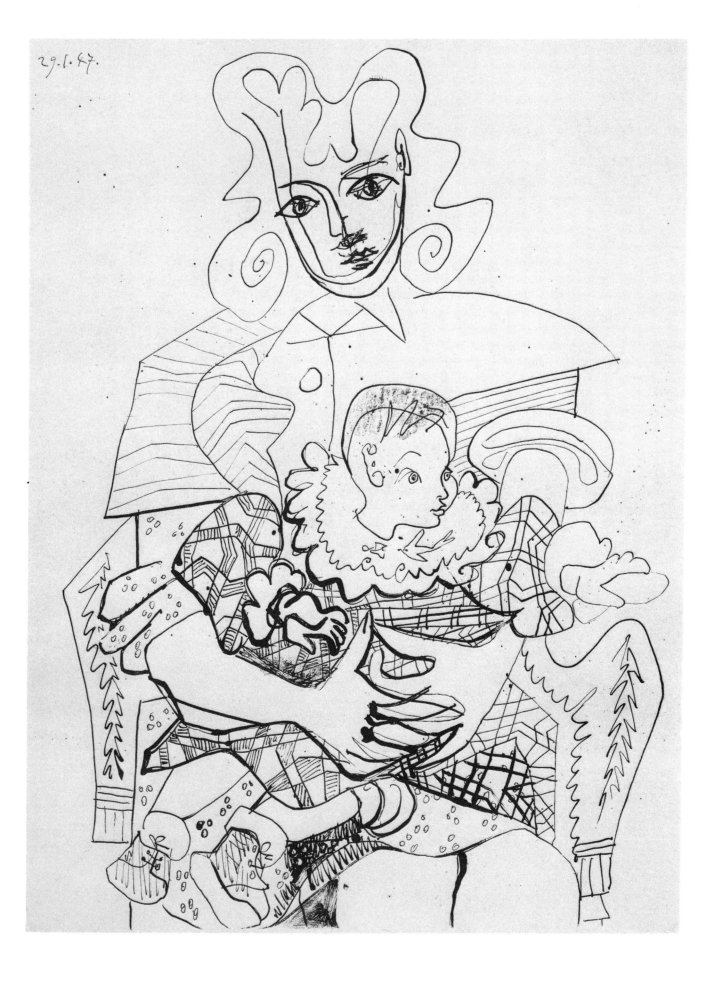

29.1.47.

INÈS AND HER CHILD. 1947. Pen and ink on litho paper, with some crayon rubbing, transferred to stone. 64 x 47 cm (25⅛ x 18½ inches).

Two Fauns and a Female Centaur. 1947. Crayon and pen and ink on litho paper transferred to stone. 49 x 64 cm (19⅜ x 25⅛ inches).

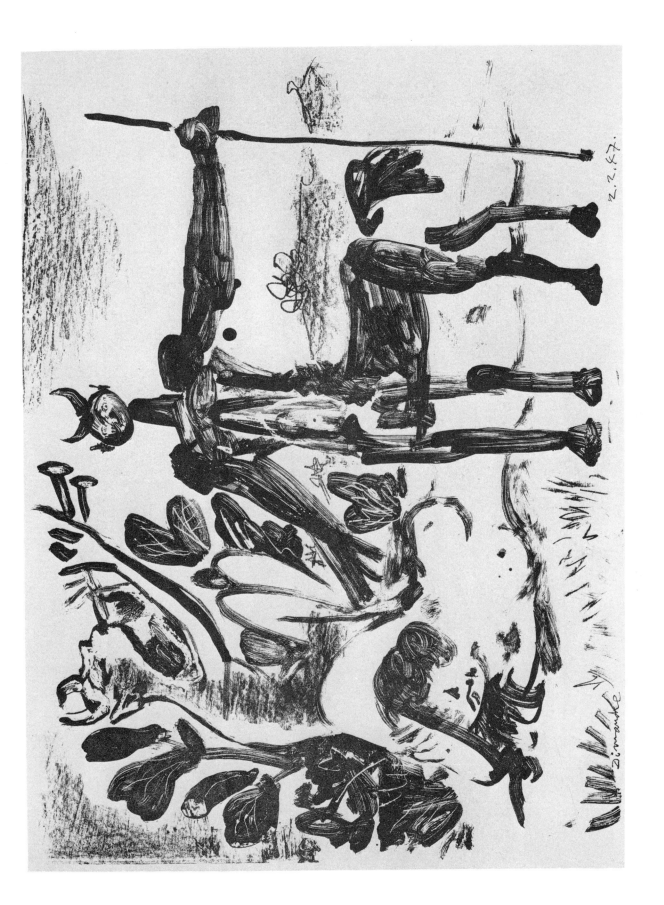

CENTAUR AND BACCHANTE WITH A FAUN. 1947. Wash and rubbed crayon, with scraper work, on litho paper transferred to stone. 49 x 64 cm (19⅜ x 25⅛ inches).

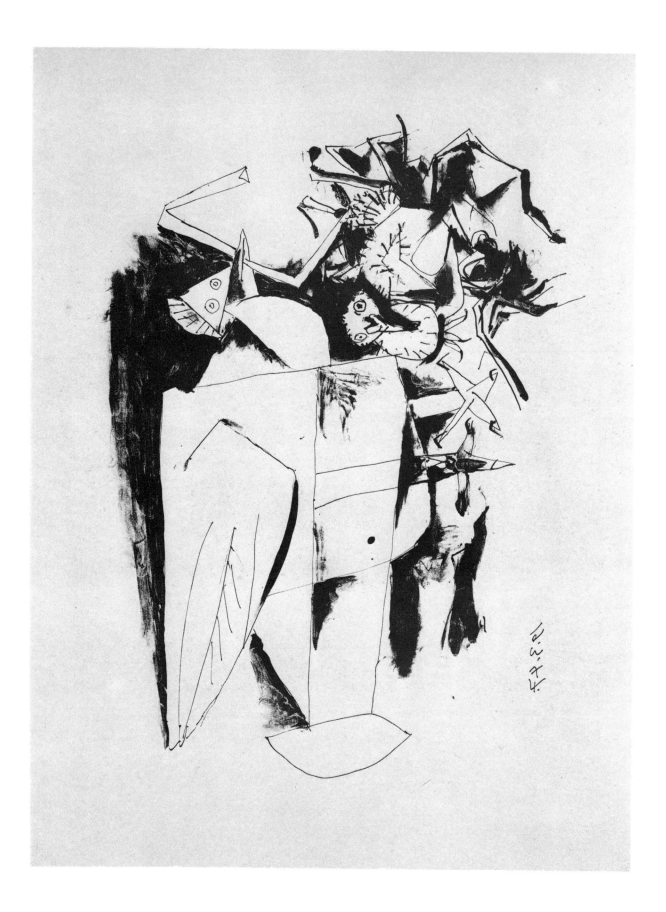

PIGEON AND YOUNG. 1947. Pen and brush on zinc. 40 x 53 cm (15¾ x 20⅞ inches).

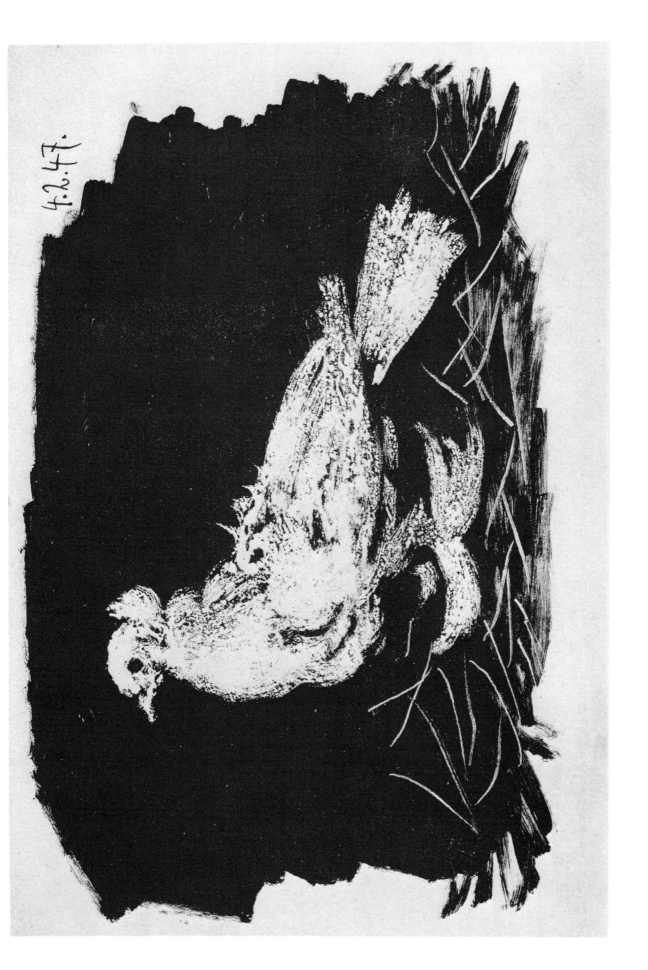

WHITE PIGEON ON BLACK BACKGROUND. 1947. Gouache wash on litho paper transferred to stone; flat-tint background; scraper work at bottom. 31 x 48 cm (12¼ x 18⅞ inches).

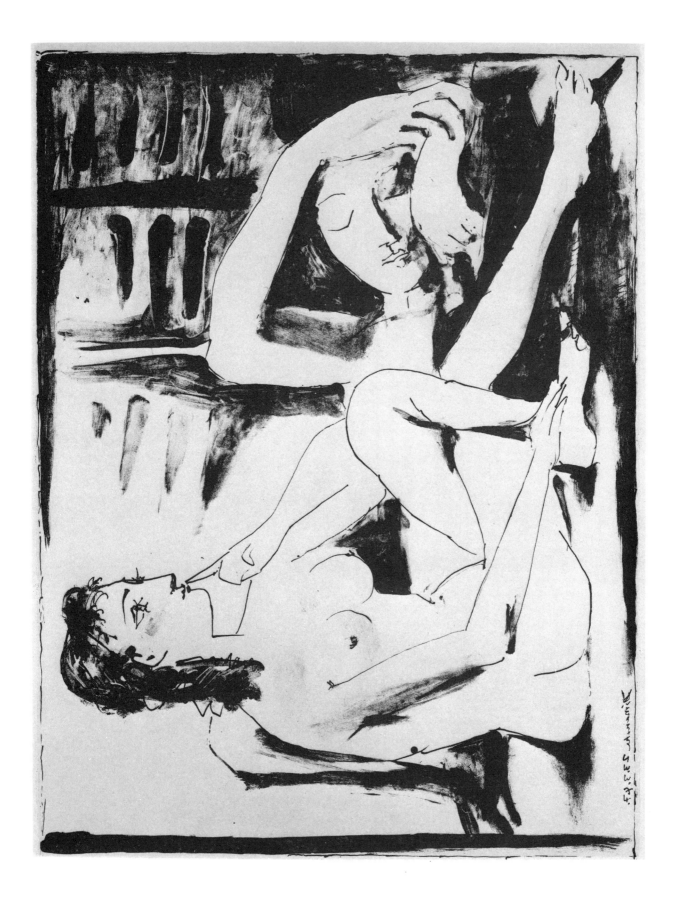

SLEEPING WOMAN. 1947. Pen and wash on zinc. 50 x 65 cm (19¾ x 25⅝ inches).

24

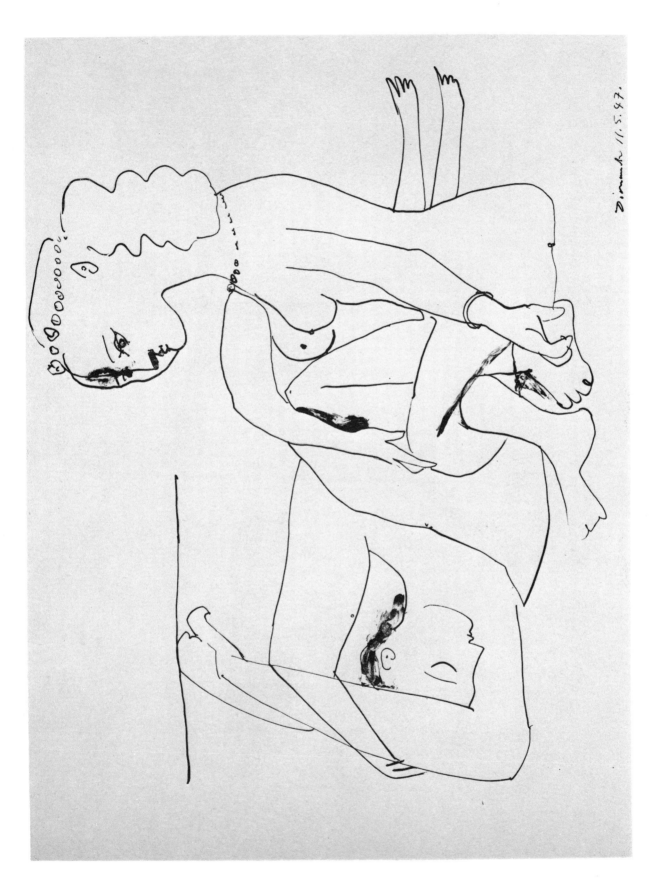

WOMEN ON THE BEACH. 1947. Pen and brush on litho paper transferred to stone. 49 x 59 cm (19⅜ x 23¼ inches).

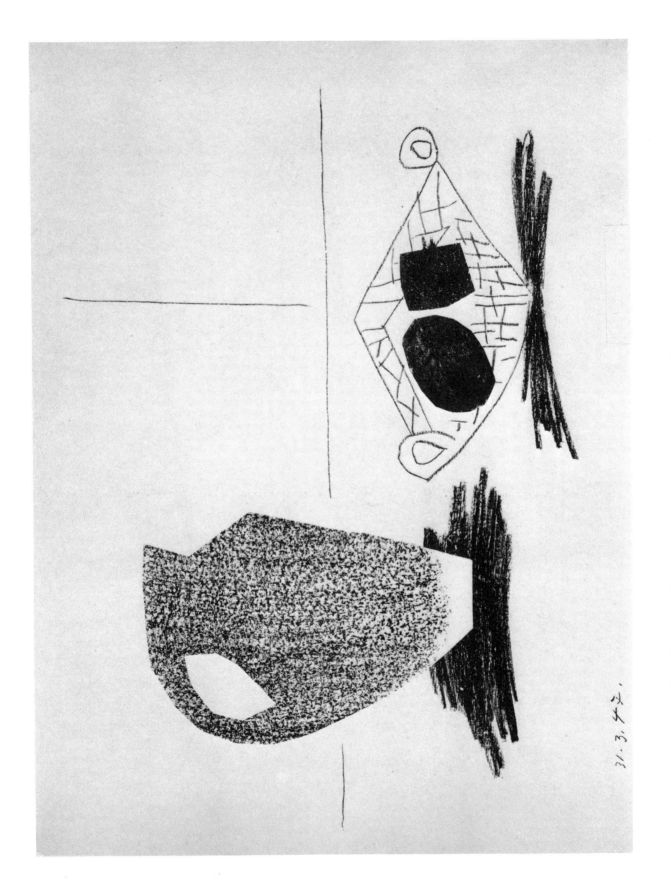

STILL LIFE WITH STONEWARE JUG. 1947. Litho paper crinkled, cut out and pasted onto a composition drawn in litho crayon, the whole then transferred to stone. 44 x 60 cm (17⅜ x 23⅝ inches).

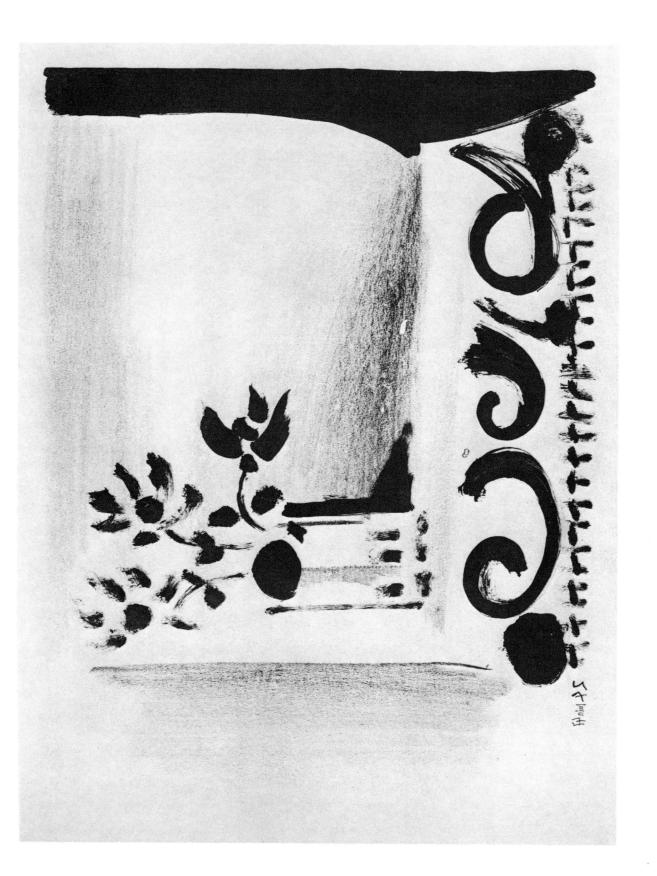

VASE OF FLOWERS AND CLOTH WITH FLORAL DESIGNS. 1947. Rubbed crayon and brush on zinc. 46 x 62 cm (18⅛ x 24⅜ inches).

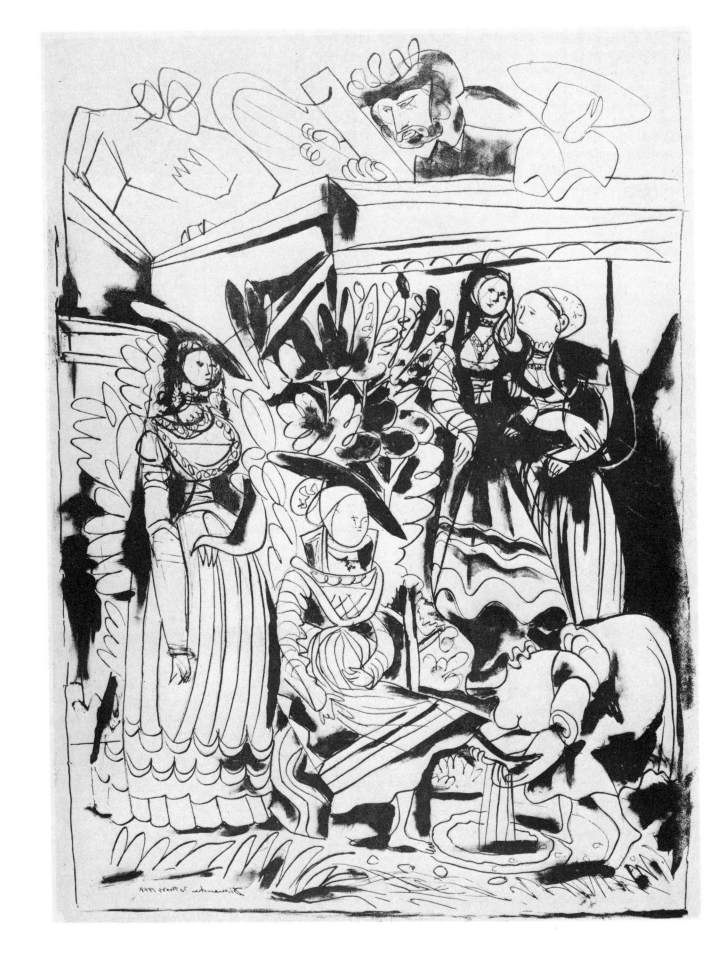

DAVID AND BATHSHEBA (variations on the painting by Lucas Cranach). First state,
March 1947. Pen and wash on zinc. 64 x 49 cm (25⅛ x 19⅜ inches).

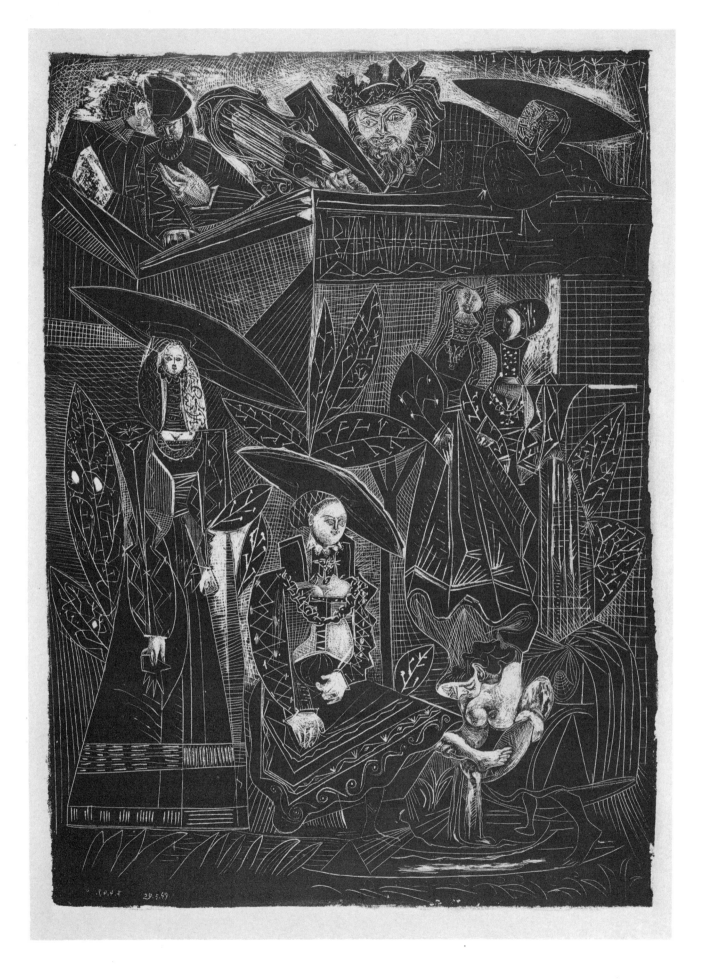

DAVID AND BATHSHEBA. Transfer onto stone of the sixth state of the
zinc plate, 1948–49.

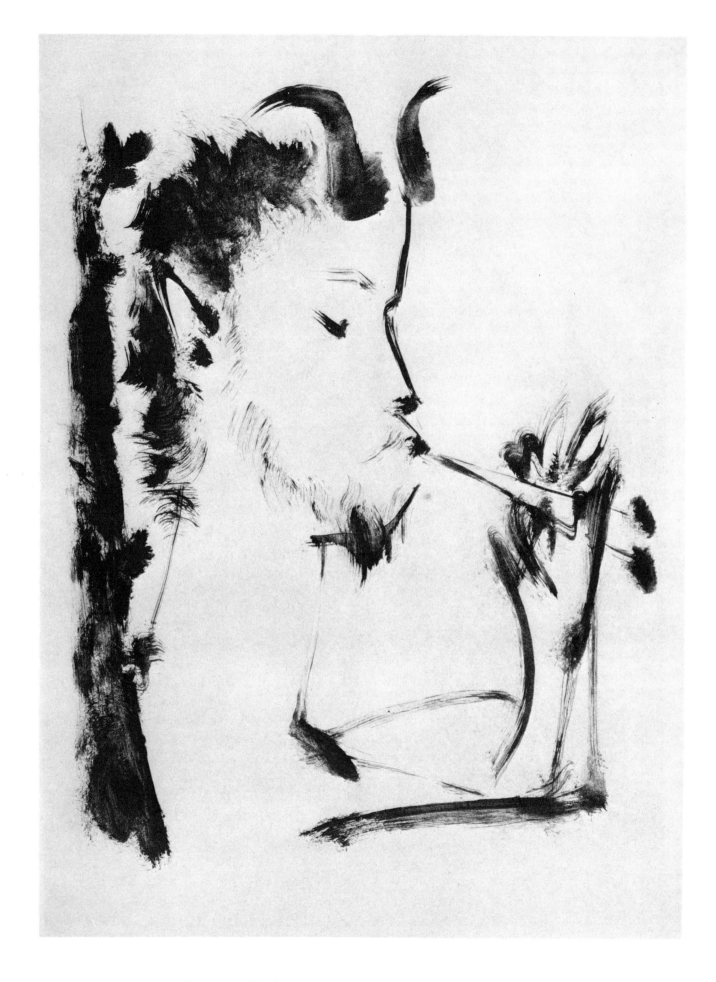

PAN. 1948. Wash on zinc. 65 x 51 cm (25⅝ x 20⅛ inches).

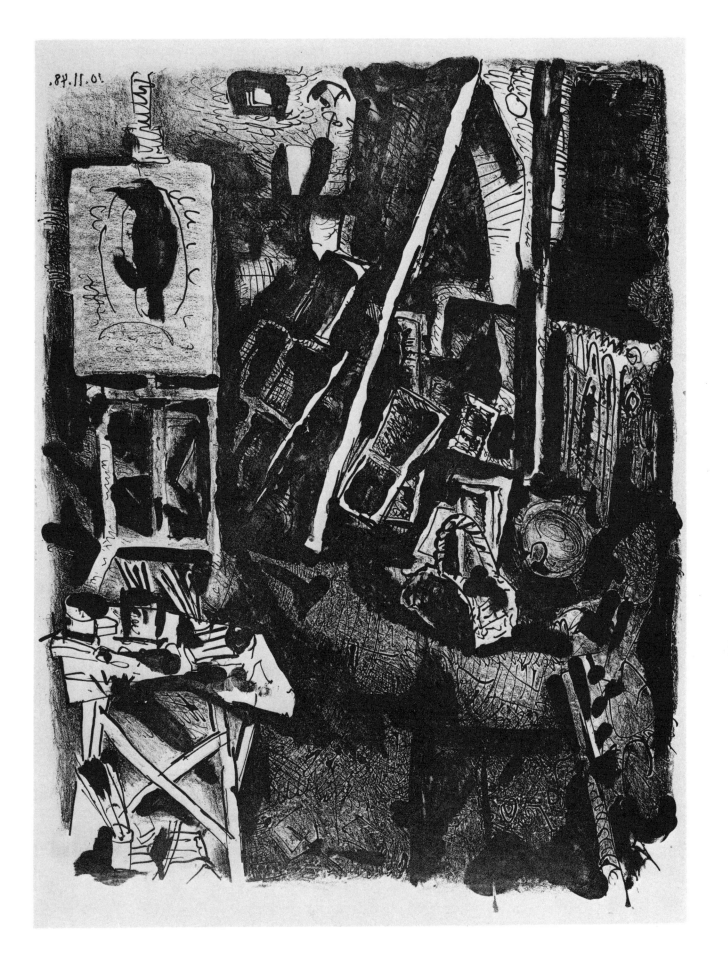

THE STUDIO (a corner of Picasso's studio on the Rue des Grands-Augustins, Paris).
1948. Crayon, pen and wash on zinc. 61 x 48 cm (24 x 18⅞ inches). 31

DANCING CENTAUR, WITH BLACK BACKGROUND. 1948. Wash, with scraper work, on litho paper transferred to stone. 50 x 65 cm (19¾ x 25⅝ inches).

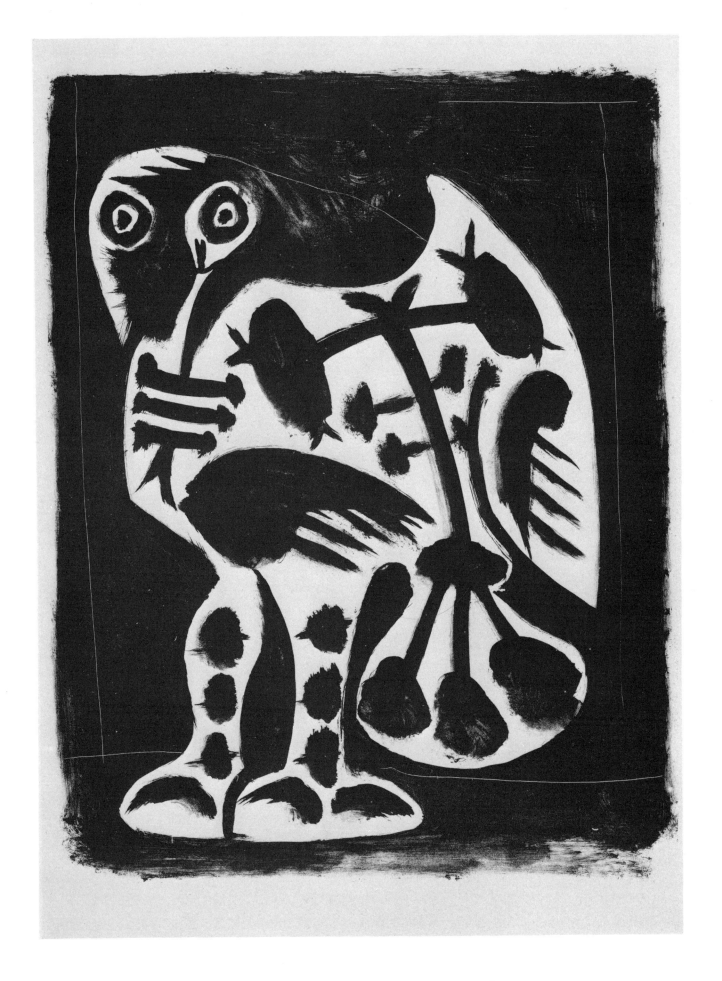

THE LARGE OWL. 1948. Wash on zinc, with scraper work. 68 x 53 cm
(26¾ x 20⅞ inches).

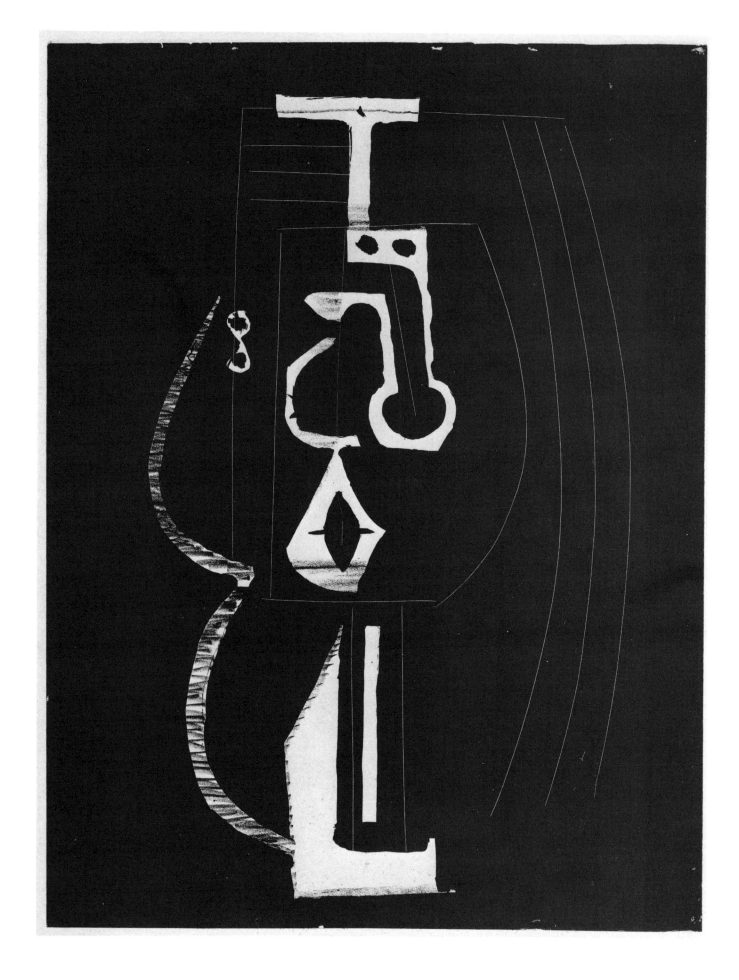

COMPOSITION. 1948. Crayon and flat tint of ink, with scraper work, on zinc.
64 x 50 cm (25⅛ x 19¾ inches).

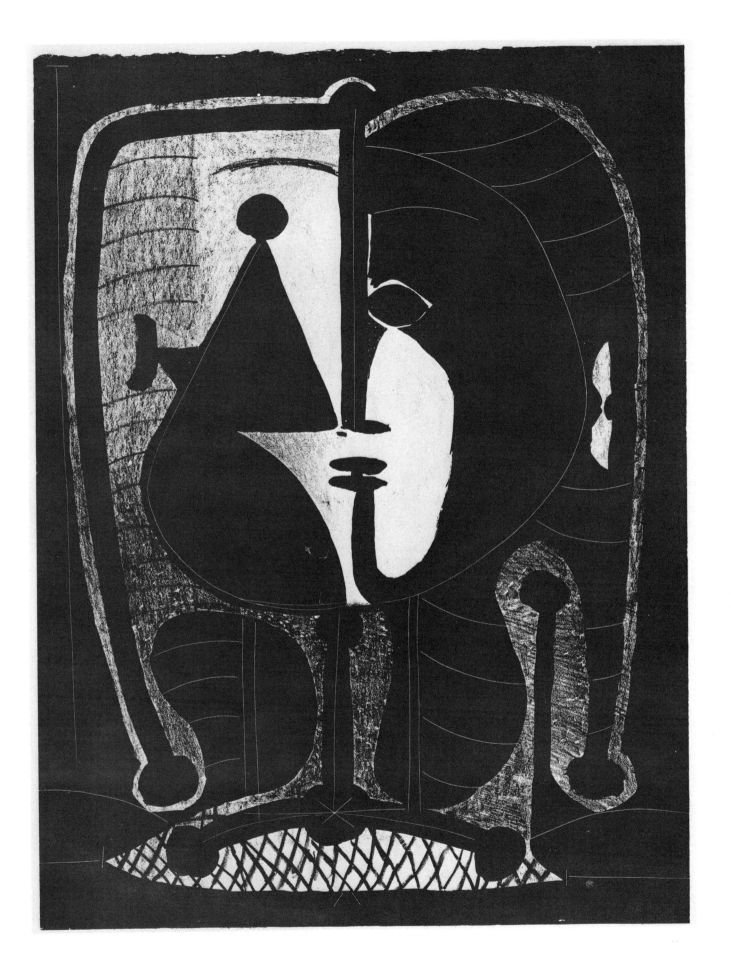

STYLIZED FACE. 1948. First state; flat tint of ink and crayon, with scraper
work, on zinc. 65 x 50 cm (25⅝ x 19¾ inches).

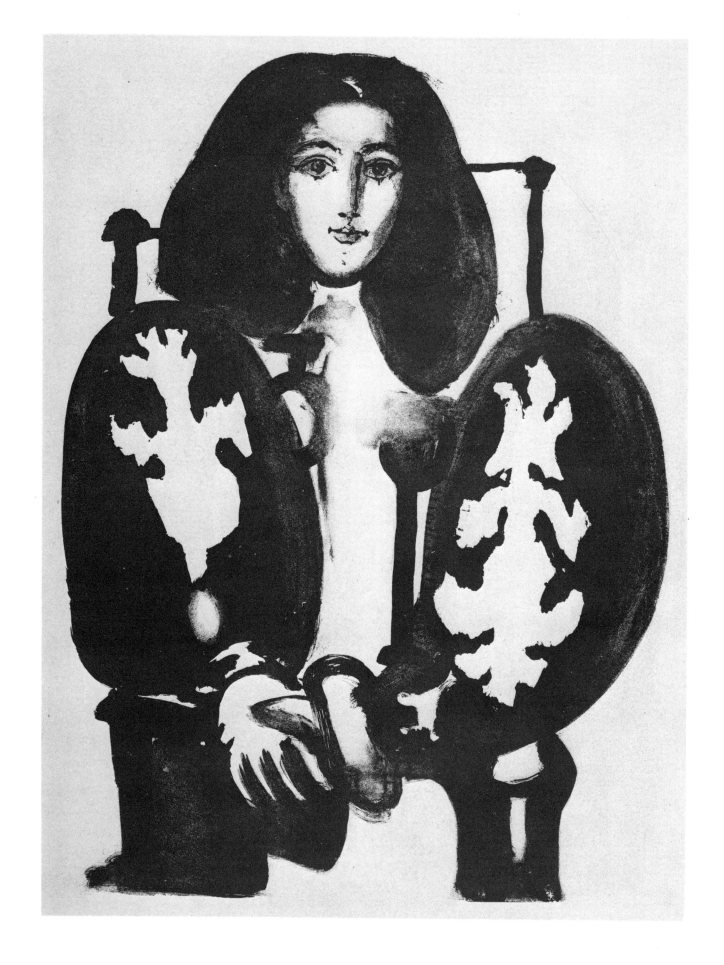

WOMAN IN AN ARMCHAIR. 1949. Wash on zinc. Definitive state of one of the zinc plates ("red plate") of a monumental 1948–49 series dealing with this subject. 65 x 50 cm (25⅝ x 19¾ inches).

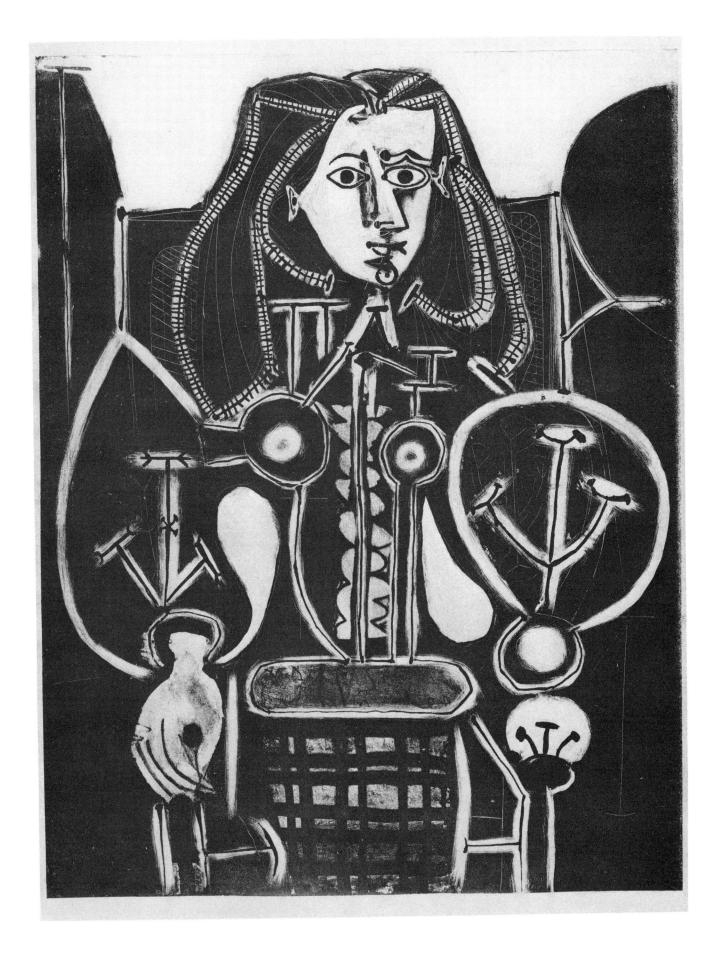

WOMAN IN AN ARMCHAIR. Fifth state of the zinc "violet plate," 1949.

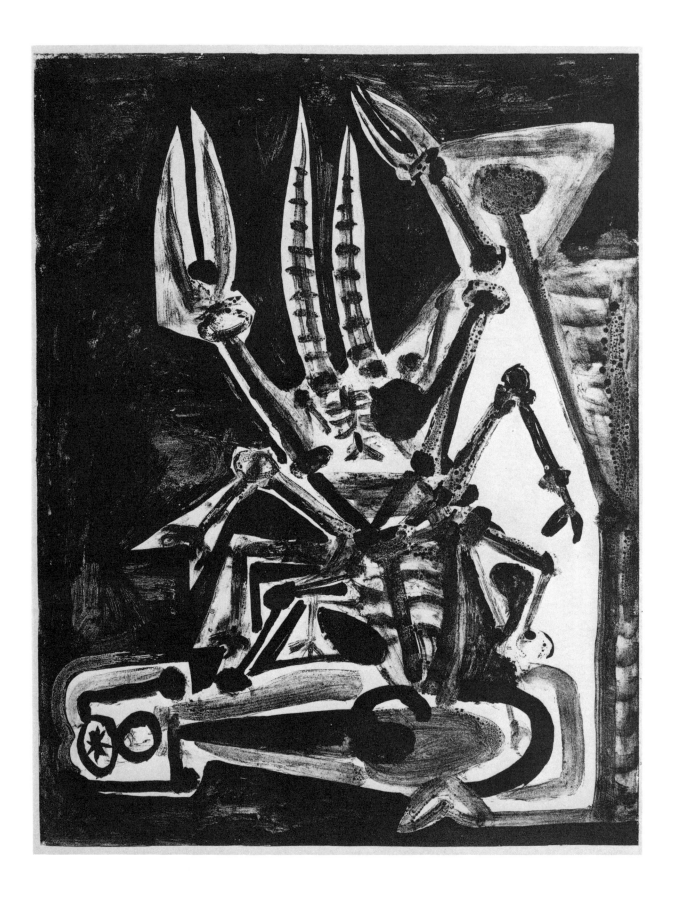

THE LOBSTER. 1949. Wash on zinc. 54.5 x 70 cm (21½ x 27½ inches).

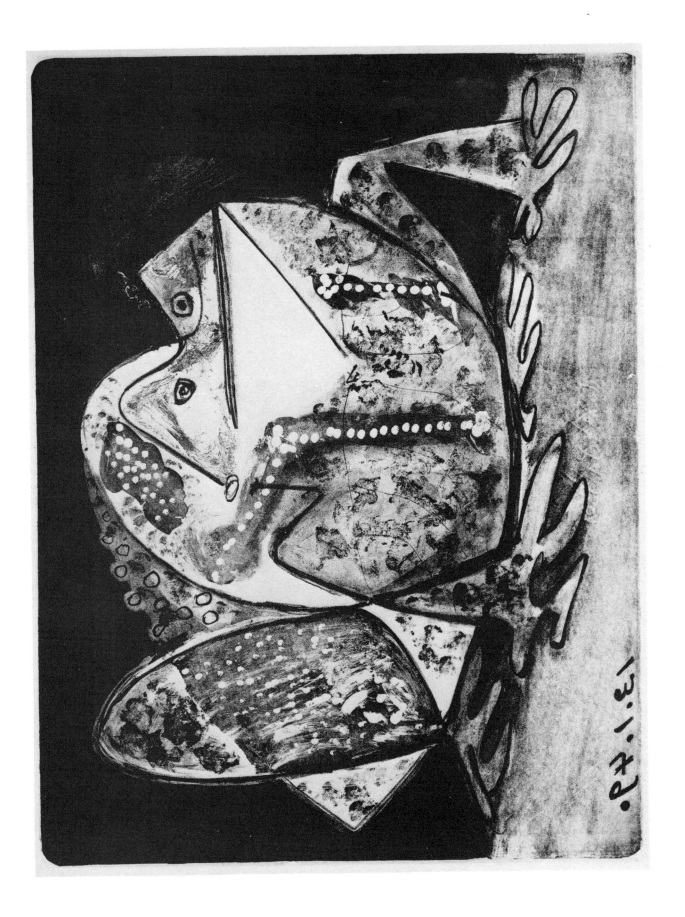

THE TOAD. 1949. Wash on zinc. 49.5 x 64 cm (19½ x 25⅛ inches).

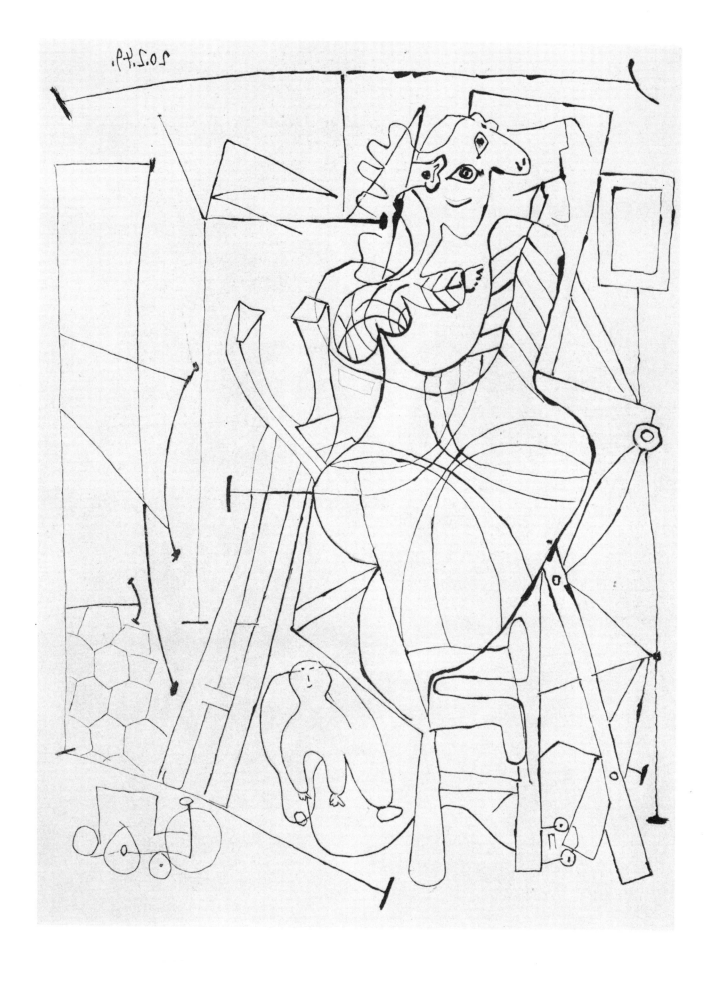

WOMAN PAINTER AND CHILD. 1949. Pen on zinc. 63 x 47 cm (24¾ x 18½ inches).

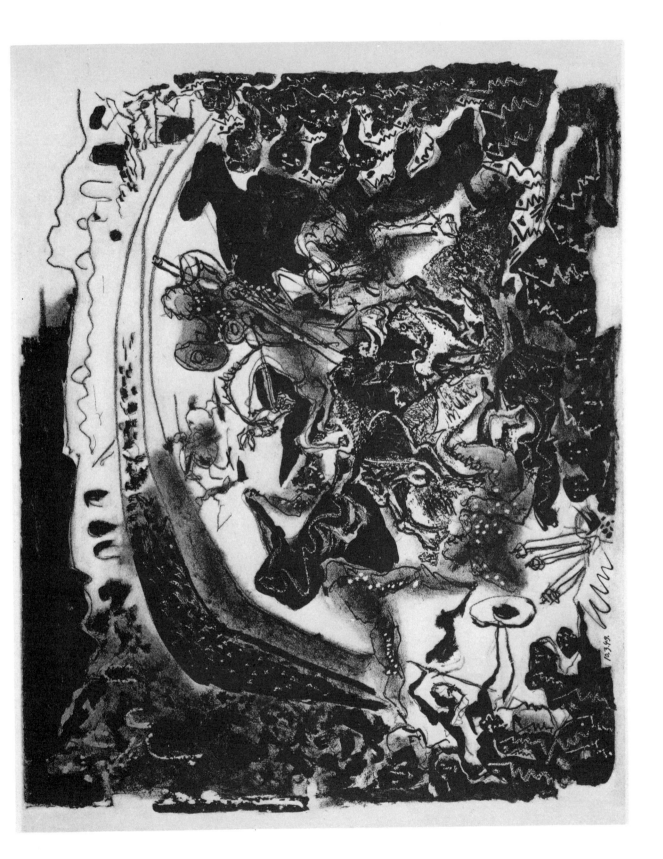

THE LARGE BULLFIGHT. 1949. First state. Crayon and wash on litho paper transferred to stone. 55 x 67 cm (21⅝ x 26⅜ inches).

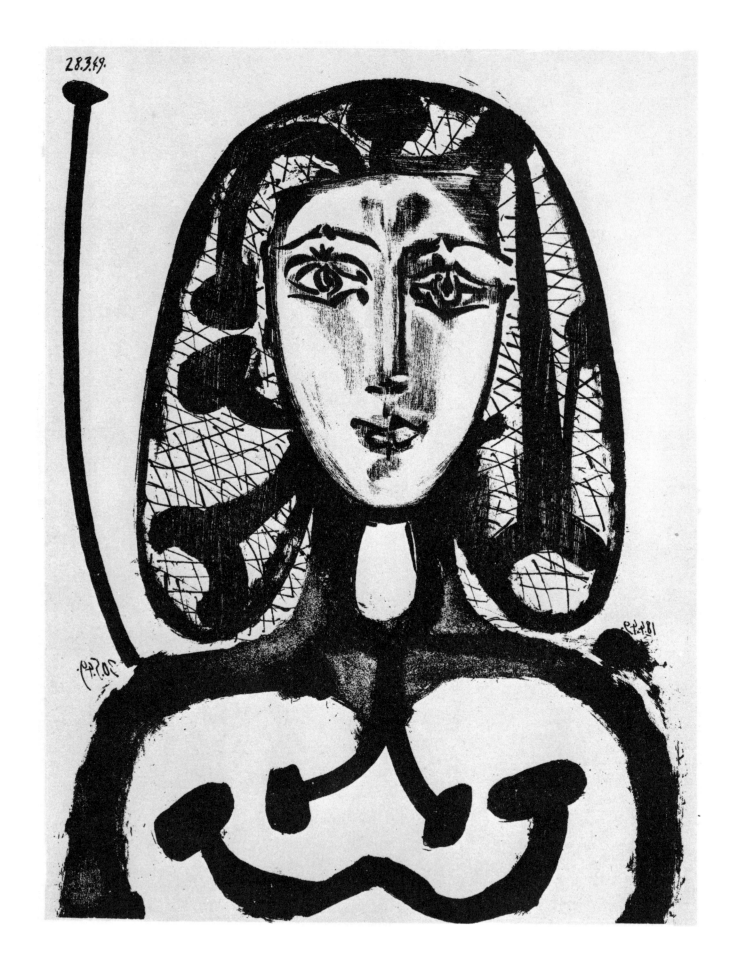

WOMAN WITH GREEN HAIR. 1949. Third state of the black plate of an intended
four-color lithograph. 65 x 50 cm (25⅝ x 19¾ inches).

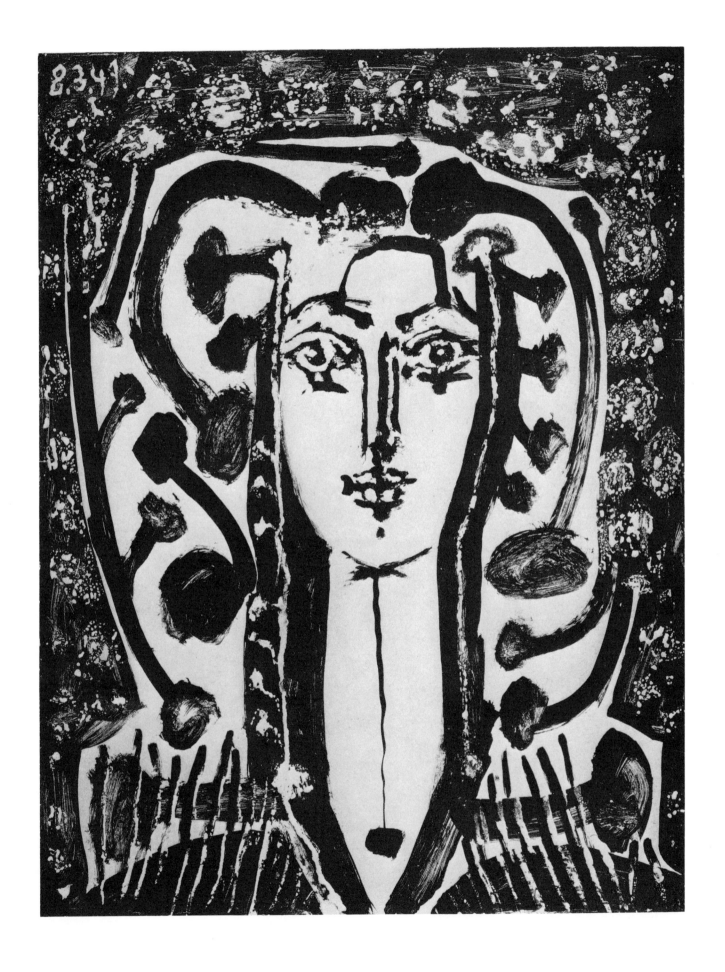

"MODERN STYLE" BUST. 1949. Wash and gouache on litho paper transferred to stone.
65 x 50 cm (25⅝ x 19¾ inches).

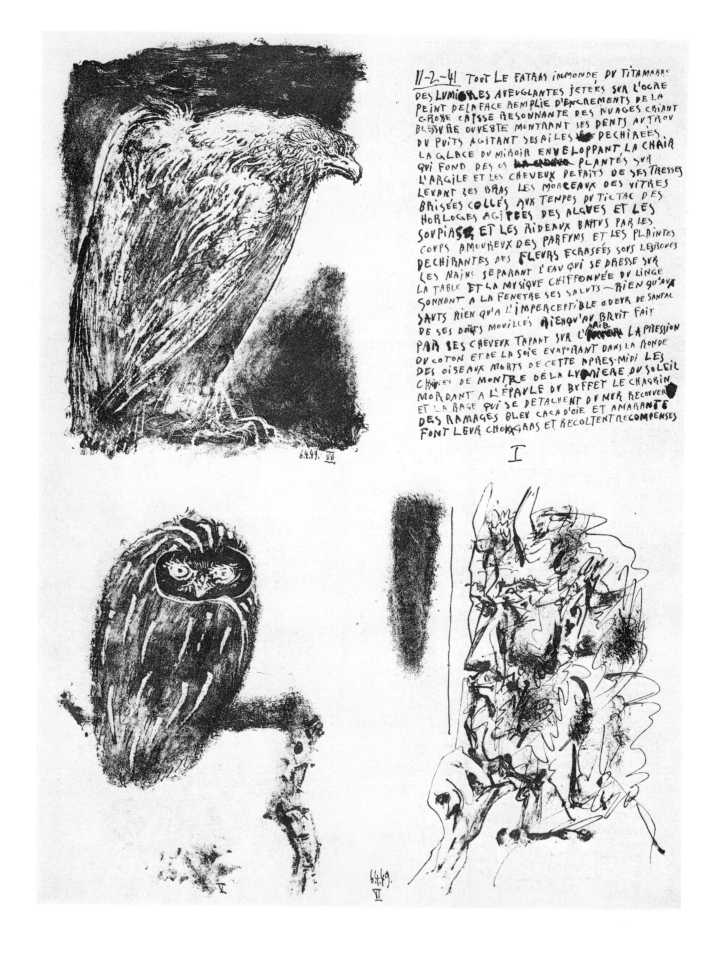

PAGE FROM A BOOK OF POEMS AND LITHOGRAPHS BY PICASSO. 1949. Mixed techniques.
65 x 50 cm (25⅝ x 19¾ inches).

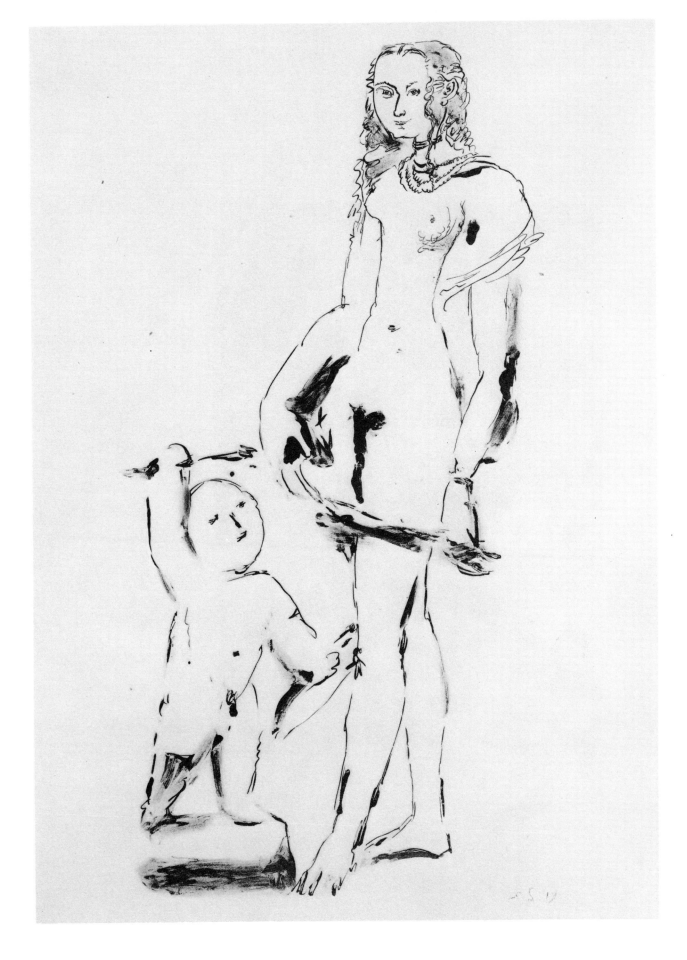

VENUS AND CUPID (third variation on the painting by Lucas Cranach). 1949.
Pen and wash in litho ink on transfer paper transferred to stone. 76 x 38 cm
(29⅞ x 15 inches).

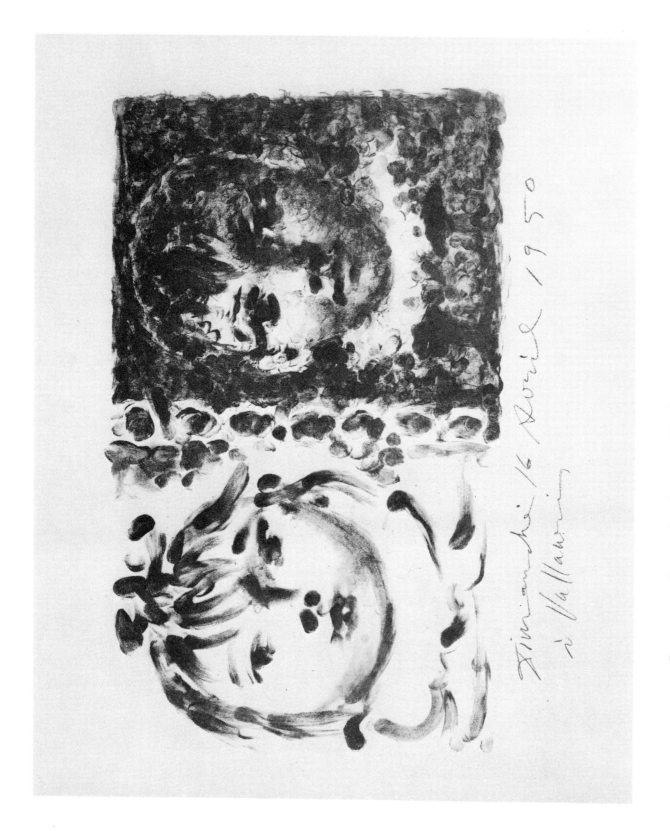

PALOMA AND CLAUDE. For the cover of Volume II of *Picasso lithographe*, 1950.
Finger-applied ink on transfer paper transferred to stone. 38 x 52 cm
(15 x 20¼ inches).

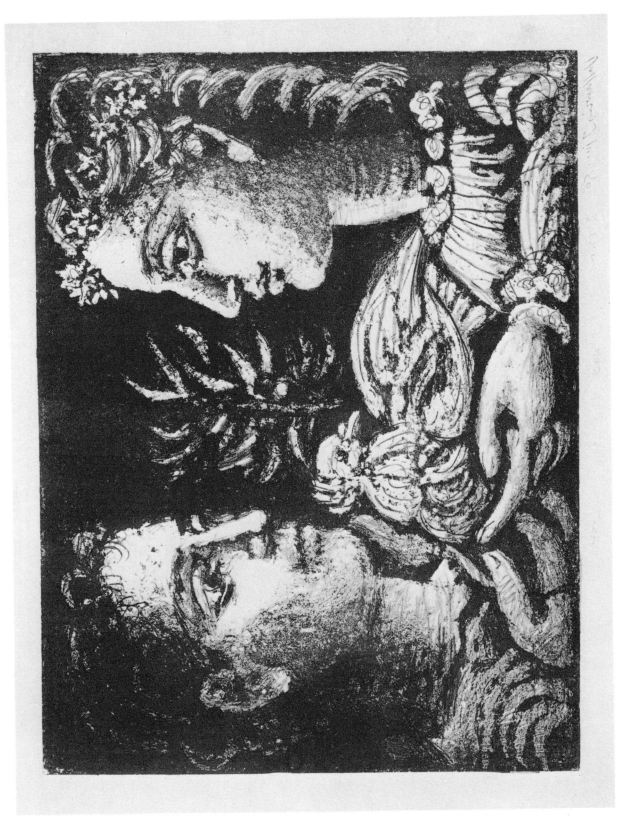

YOUTH. 1950. Second state. For a poster advertising a Franco-Italian friendship meeting in Nice. Litho crayon and ink on zinc. 50 x 65 cm. (19¾ x 25⅝ inches).

47

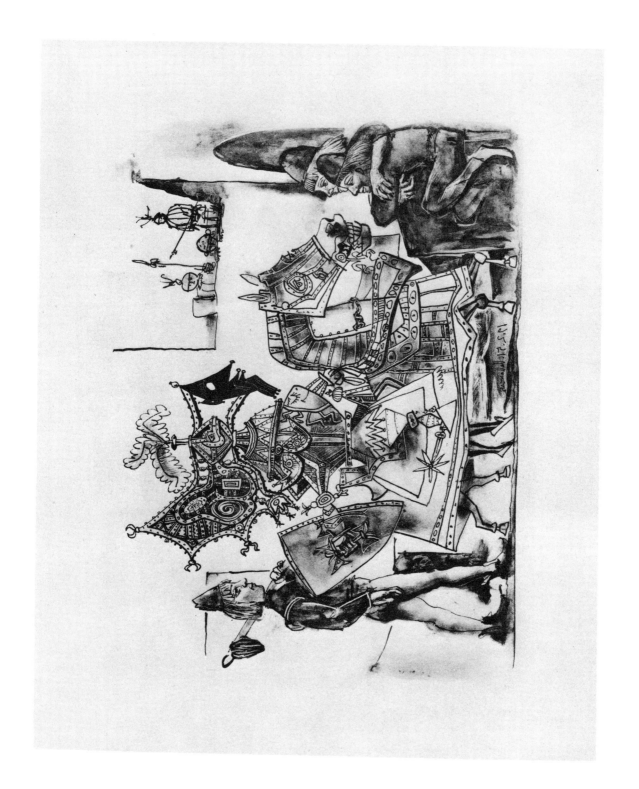

AMUSEMENTS OF THE PAGES (part of a long series on knights). 1951. Pen and litho crayon on stone, with scraper work. 32 x 42.5 cm (12⅝ x 16¾ inches).

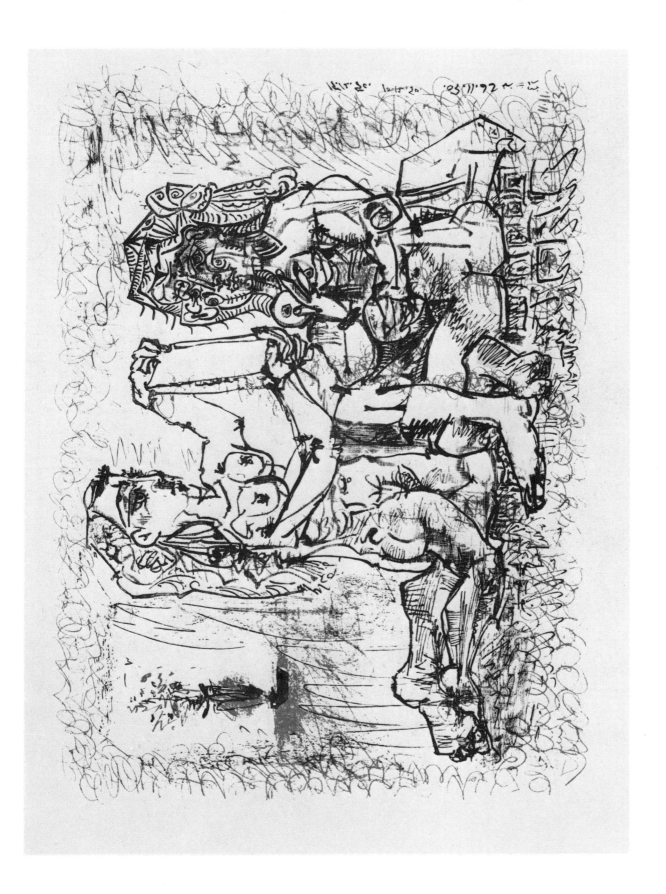

WOMAN WITH A MIRROR. Fourth state, 1953 (series begun 1950). Zinc black plate with a second color (bistre) in litho crayon. 40 x 52 cm (15¾ x 20½ inches).

FLYING DOVE. 1952. Litho crayon and gouache on transfer paper transferred to stone. 45 x 62 cm (17³/₄ x 24³/₈ inches).

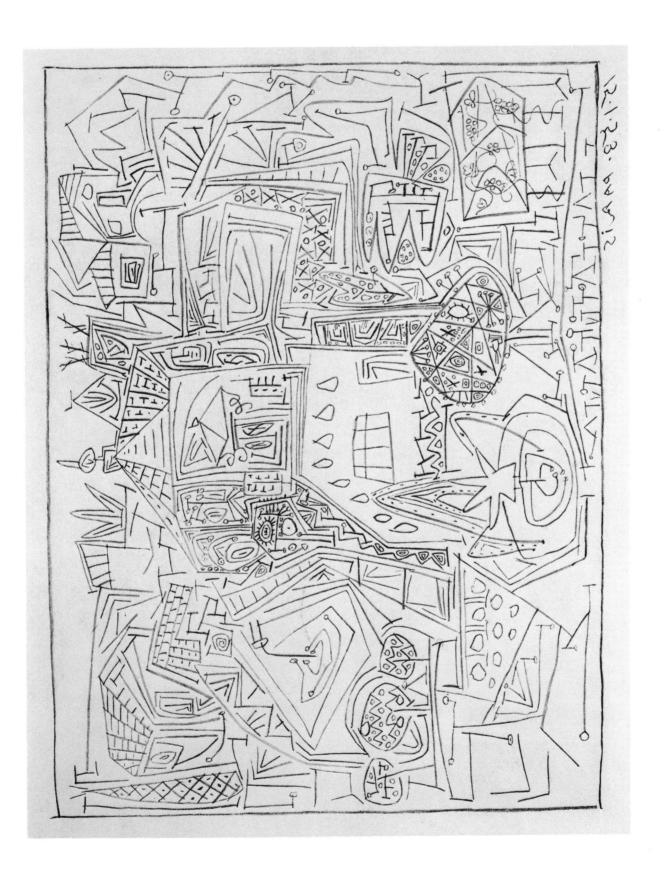

GARDENS AT VALLAURIS. 1953. Litho crayon on zinc. 51 x 64 cm (20⅛ x 25⅛ inches).

51

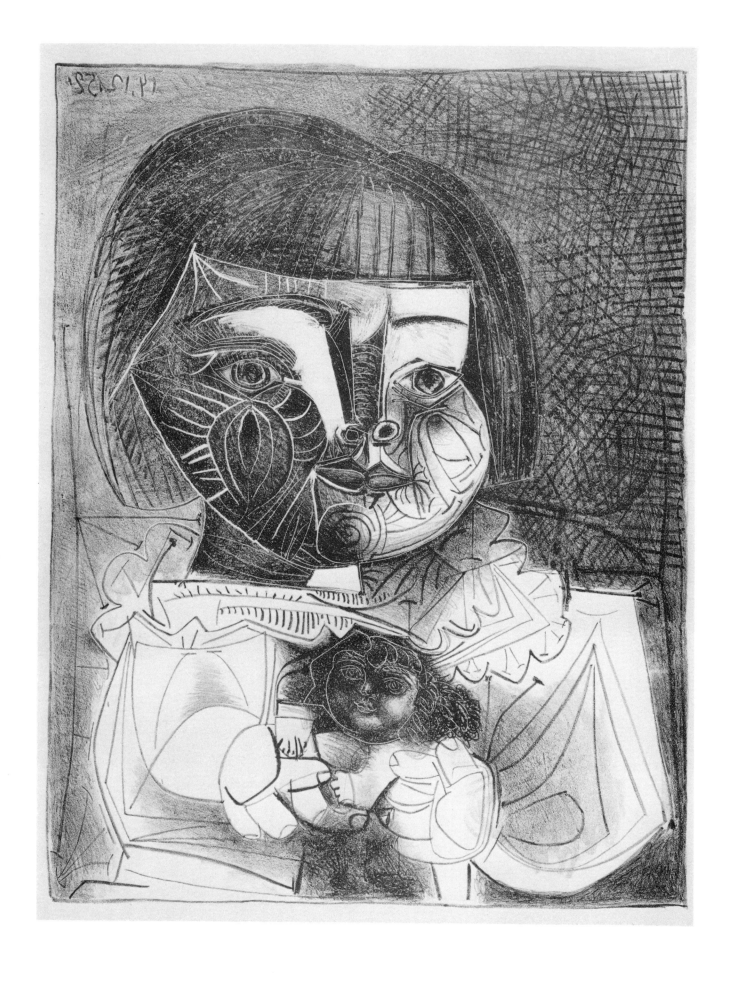

PALOMA AND HER DOLL, WITH BLACK BACKGROUND. 1952. Litho crayon on zinc, with
scraper work. 70 x 55 cm (27½ x 21⅝ inches).

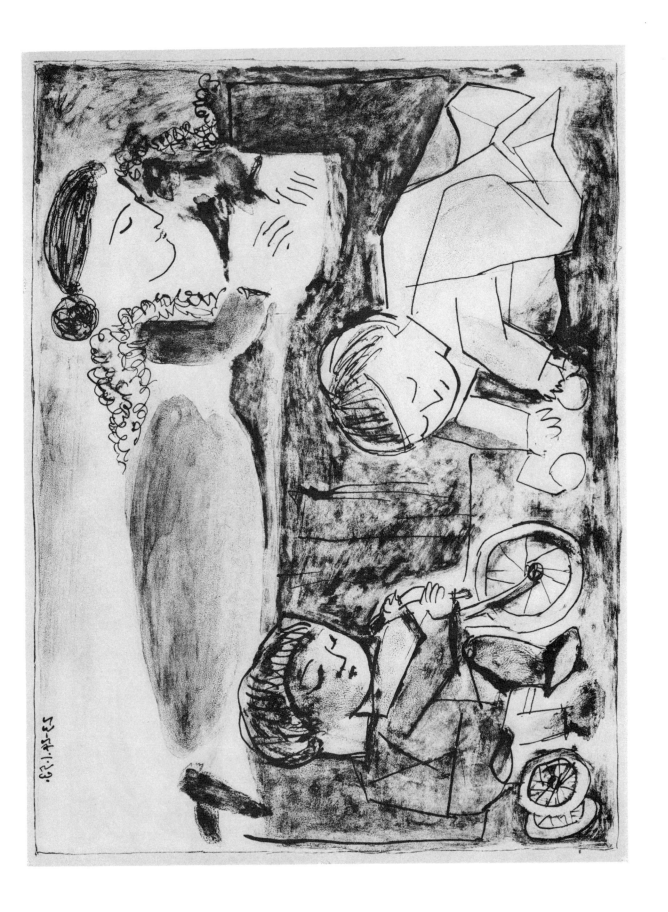

PLAYING GAMES AND READING. 1953. Wash and pen on zinc. 48 x 63 cm (18⅞ x 24¾ inches).

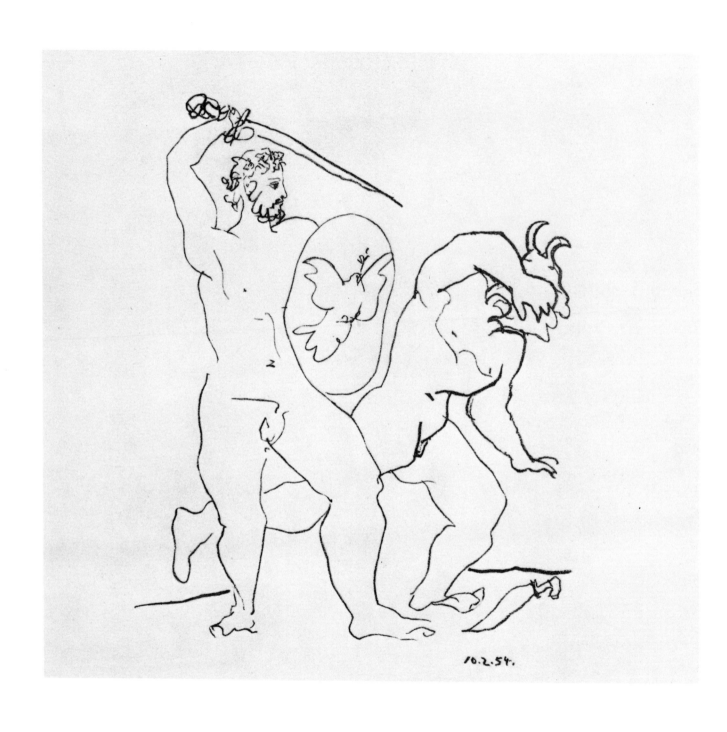

WAR AND PEACE. Frontispiece to the deluxe edition of Claude Roy's *La Guerre et la Paix*, 1954. 24 x 30 cm (9⅜ x 11⅞ inches).

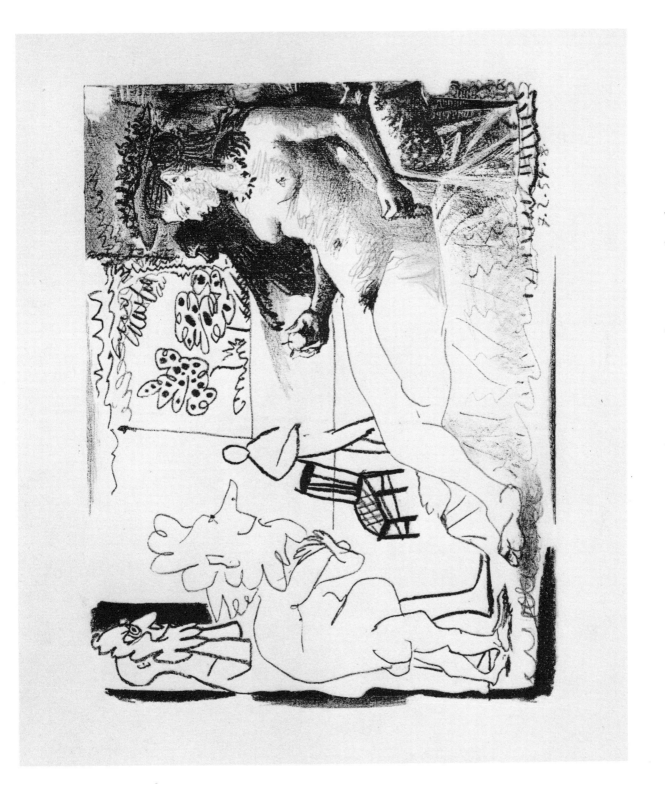

WOMAN WITH A MONKEY. 1954. Litho crayon on transfer paper transferred to stone. 25 x 32 cm (9⅞ x 12⅝ inches.)

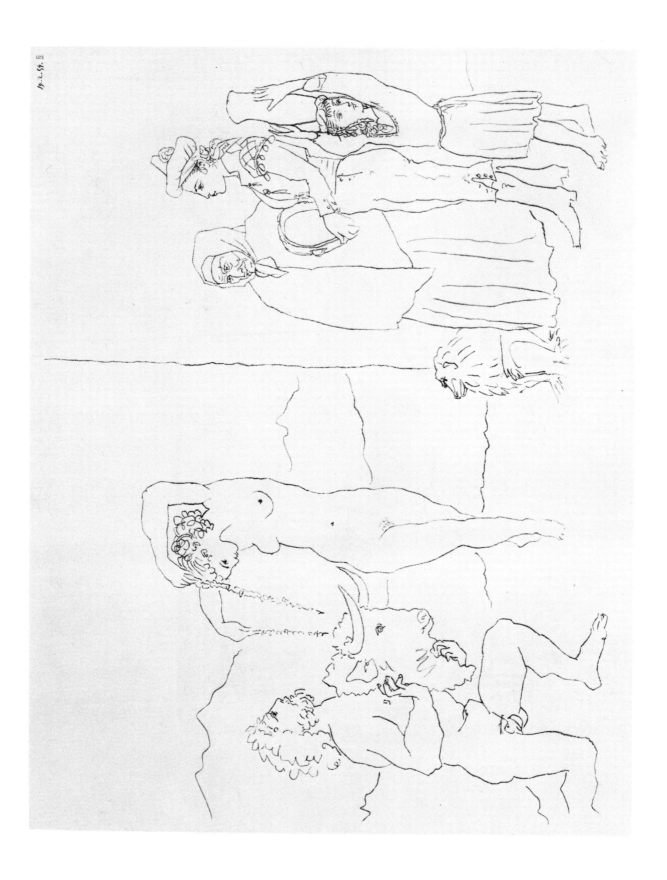

DANCE WITH BANDERILLAS. 1954. Litho crayon on transfer paper transferred to stone. 48 x 64 cm (18⅞ x 25⅛ inches).

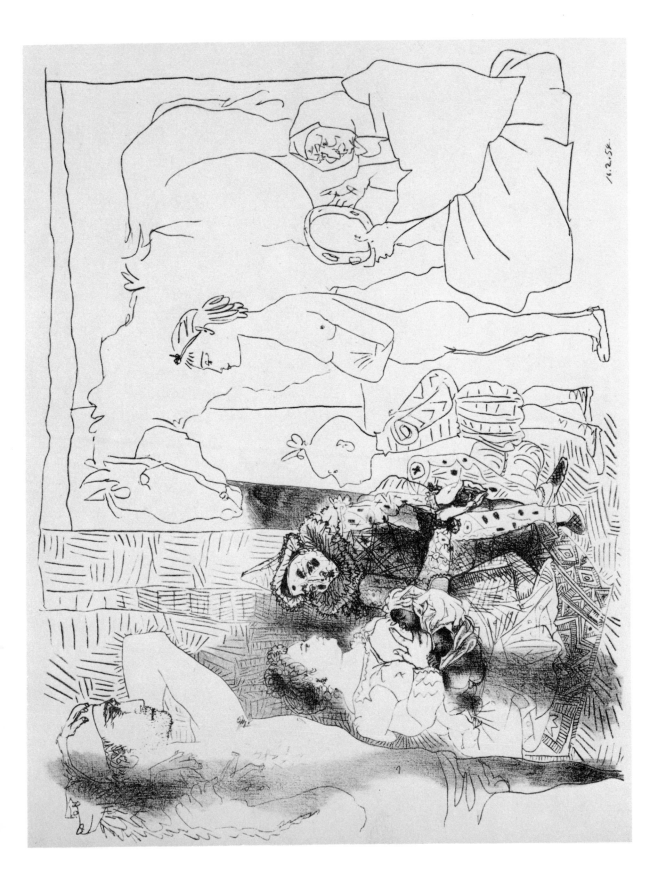

THE STREET ACROBAT'S FAMILY. 1954. Litho crayon on transfer paper transferred to stone. 50 x 64 cm (19¾ x 25⅛ inches).

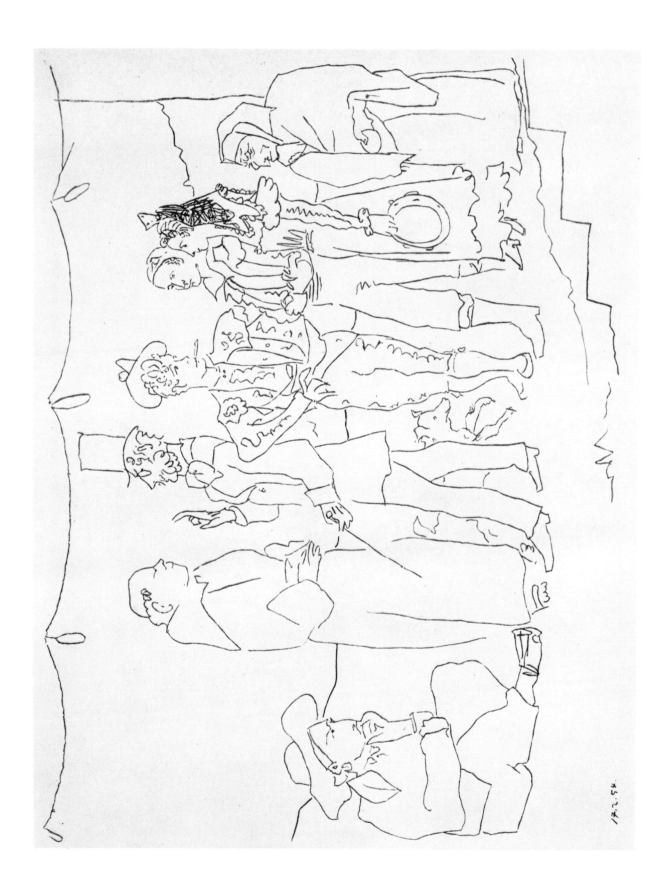

TROUPE OF ACTORS. 1954. Litho crayon on transfer paper transferred to stone. 49 x 64 cm (19¼ x 25⅛ inches).

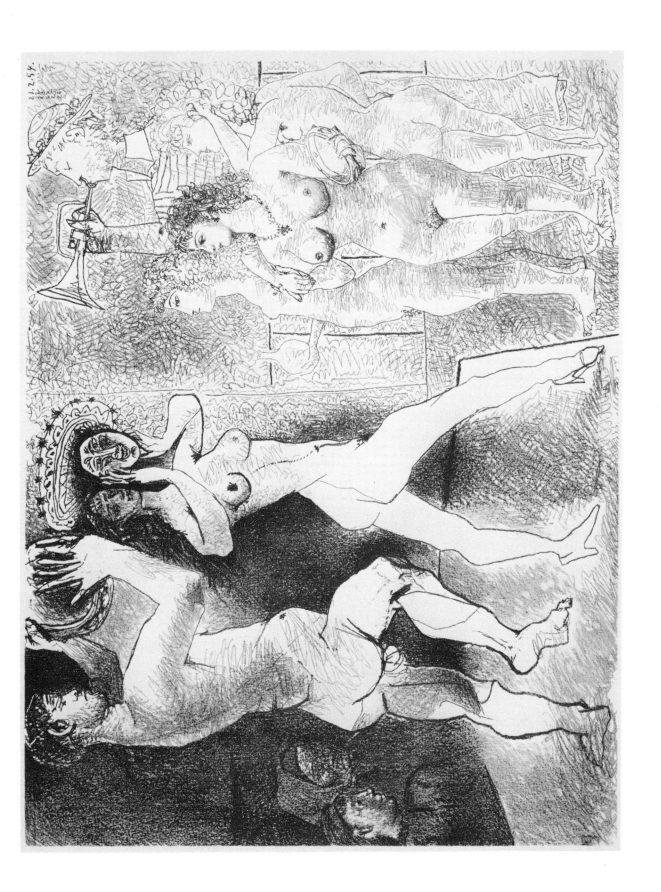

THE REHEARSAL. 1954. Litho crayon on transfer paper transferred to stone. 49.5 x 65 cm (19½ x 25⅝ inches).

59